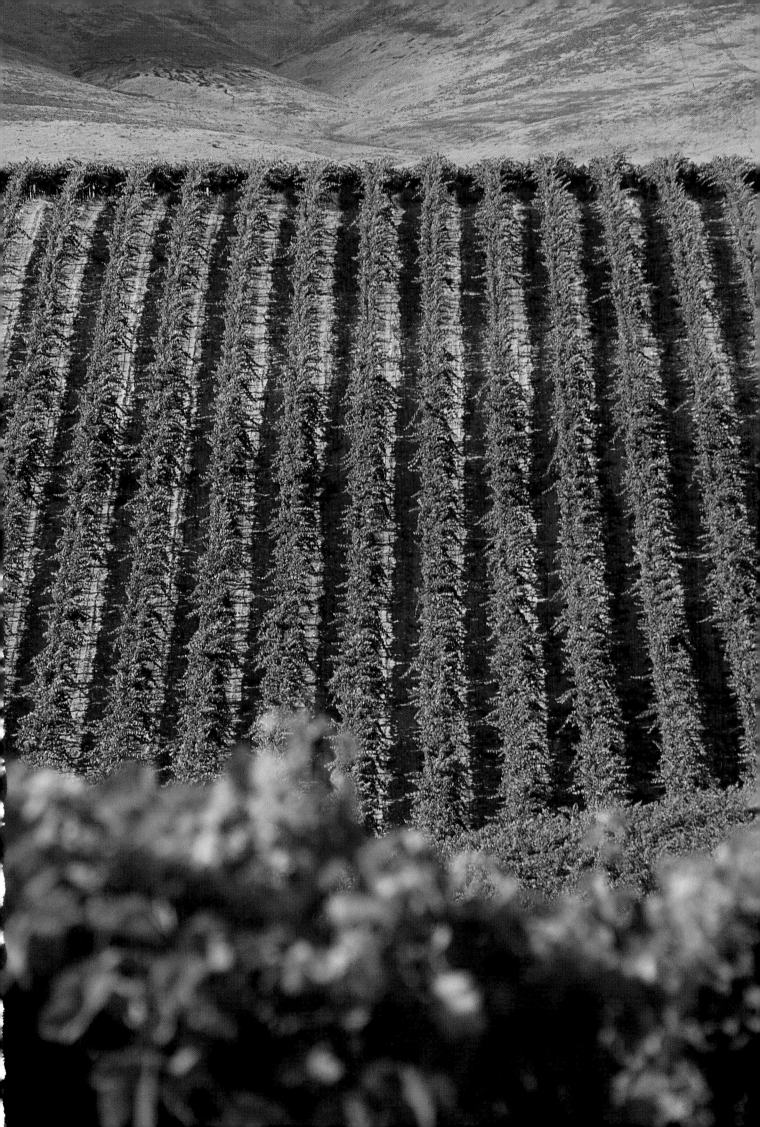

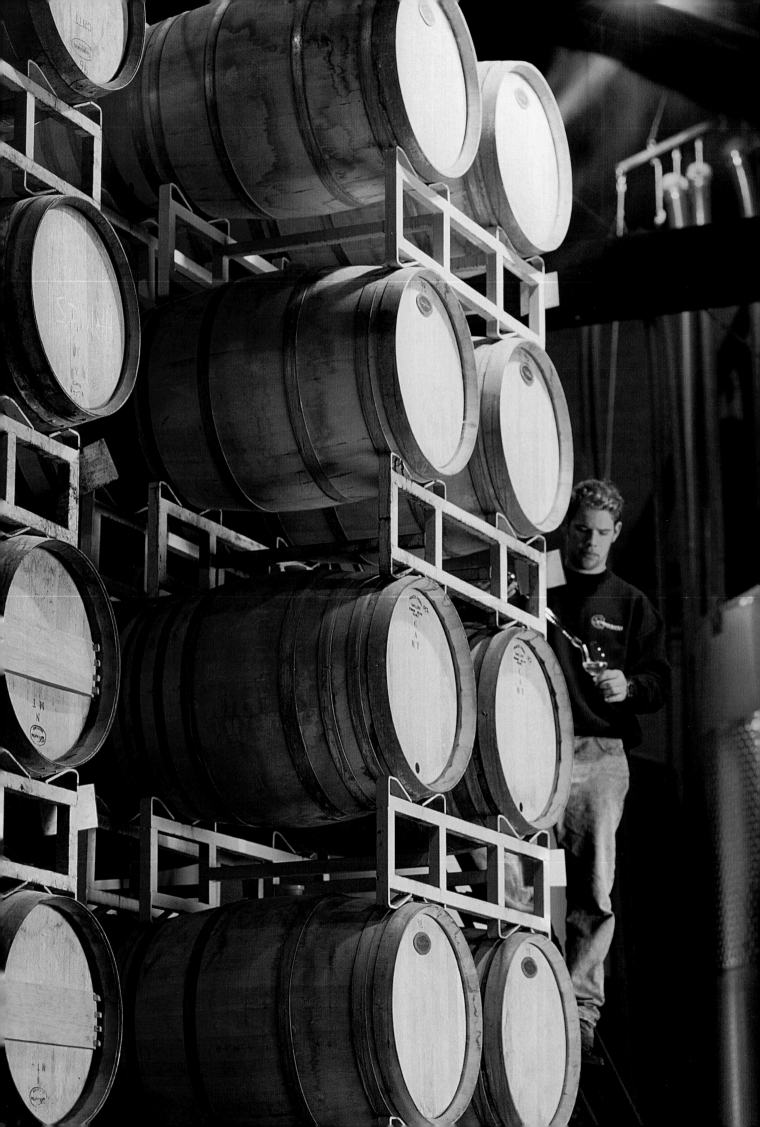

WASHINGTON
WINE
COUNTRY

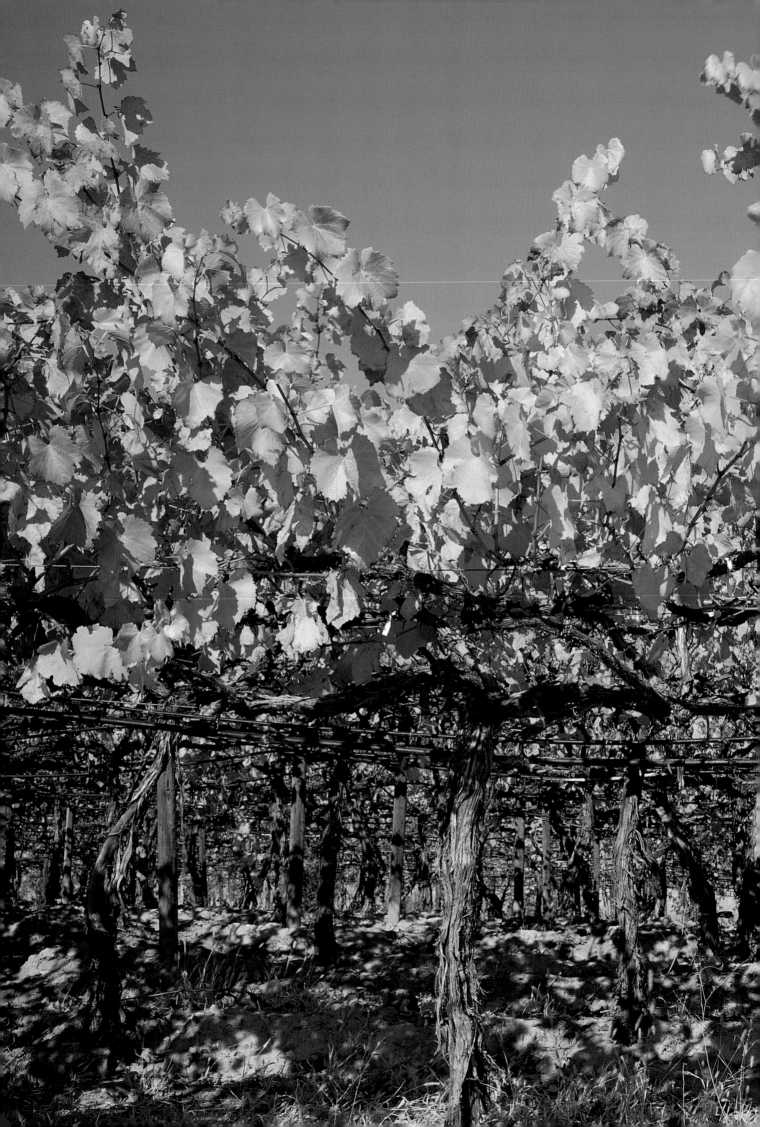

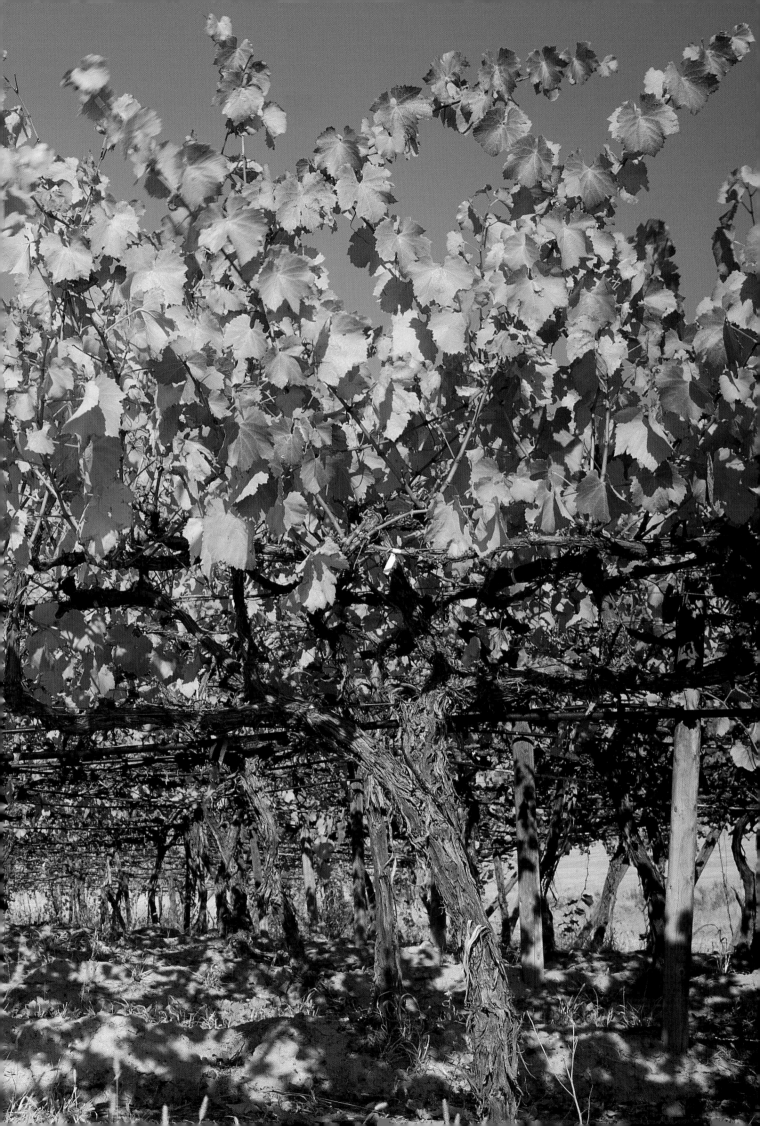

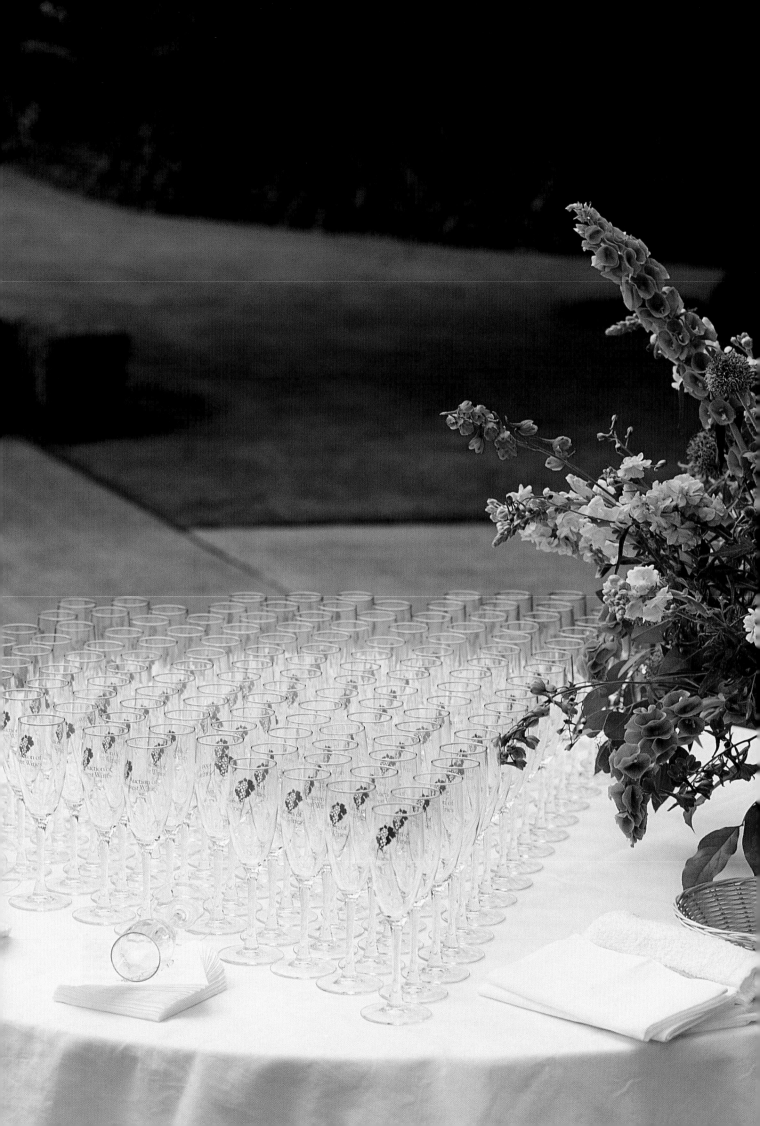

WASHINGTON
WINE
COUNTRY

Photography Robert M. Reynolds
Text Judy Peterson-Nedry

Graphic Arts Center Publishing®

All photos except for page 83 © MM by Robert M. Reynolds
Photo page 83 © MM by Charles Blackburn
Text © MM by Judy Peterson-Nedry
Book compilation © MM by Graphic Arts Center Publishing®
An imprint of Graphic Arts Center Publishing Company
P.O. Box 10306, Portland, Oregon 97296-0306, 503/226-2402
www.gacpc.com

Library of Congress Cataloging-in-Publication Data

Reynolds, Robert M. (Robert Moland)
 Washington wine country / photography, Robert M. Reynolds ;
 text, Judy Peterson-Nedry.
 p. cm.
 ISBN 1-55868-528-6 (pbk: alk. paper)
 ISBN 1-55868-503-0 (hardcover alk. paper)
 1. Wine and wine making—Washington (State)—Pictorial
 works. I. Peterson-Nedry, Judy. II. Title.

TP557.R495 2000
641.2'2'09797—dc21

 99-057154

President: Charles M. Hopkins

Editorial Staff: Douglas A. Pfeiffer, Timothy W. Frew,
 Ellen Harkins Wheat, Tricia Brown, Jean Andrews,
 Alicia I. Paulson, Julia Warren

Production Staff: Richard L. Owsiany,
 Heather Doornink

Design: Reynolds/Wulf Design, Inc.
 Robert M. Reynolds, Letha Gibbs Wulf

Freelance Editor: Don Graydon

Map Artist: John Fretz

Printed and bound in the United States of America

Page 1: Situated in the foothills of the Cascade Mountain Range,
Red Willow Vineyard, owned by Mike Sauer and his family, is
located at the westernmost edge of the fertile Yakima Valley.
Page 2: A cellar worker "thiefs" a sample of red wine in the bar-
rel room at Canoe Ridge Winery in Walla Walla. Pages 4-5: High
trellised vines turn color and begin to shed foliage in the Yakima
Valley's bright Indian summer. Page 6: Hundreds of sparkling
wine glasses await guests at the annual Auction of Northwest Wines,
held annually since 1988 at Chateau Ste. Michelle winery in
Woodinville. Page 9: Lisa Facelli-Lucarelli, assistant winemaker
at Facelli Winery in Woodinville, samples 1998 Merlot from the
barrel. Page 11: Ornate Victorian details grace the fanciful
entrance of Columbia Winery in Woodinville. Pages 12-13: Day
breaks among Gewürztraminer vines at the Thomas Woodward
Vineyard on the Washington side of the Columbia River.

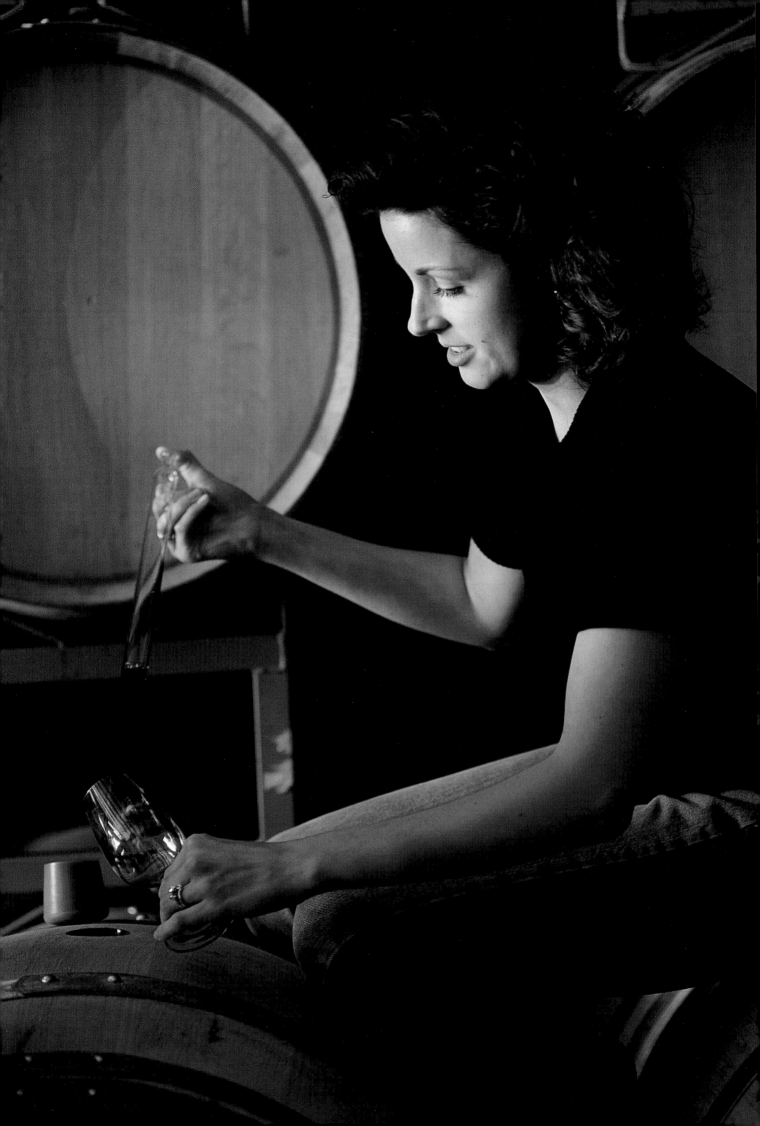

Contents

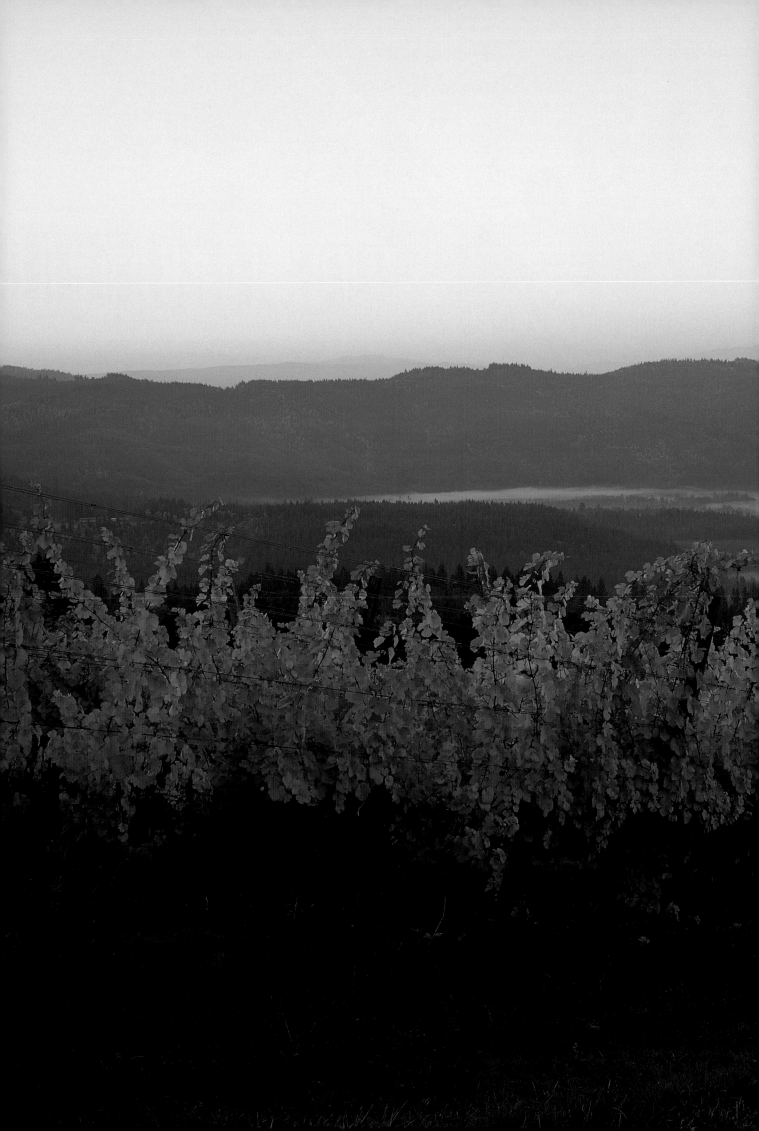

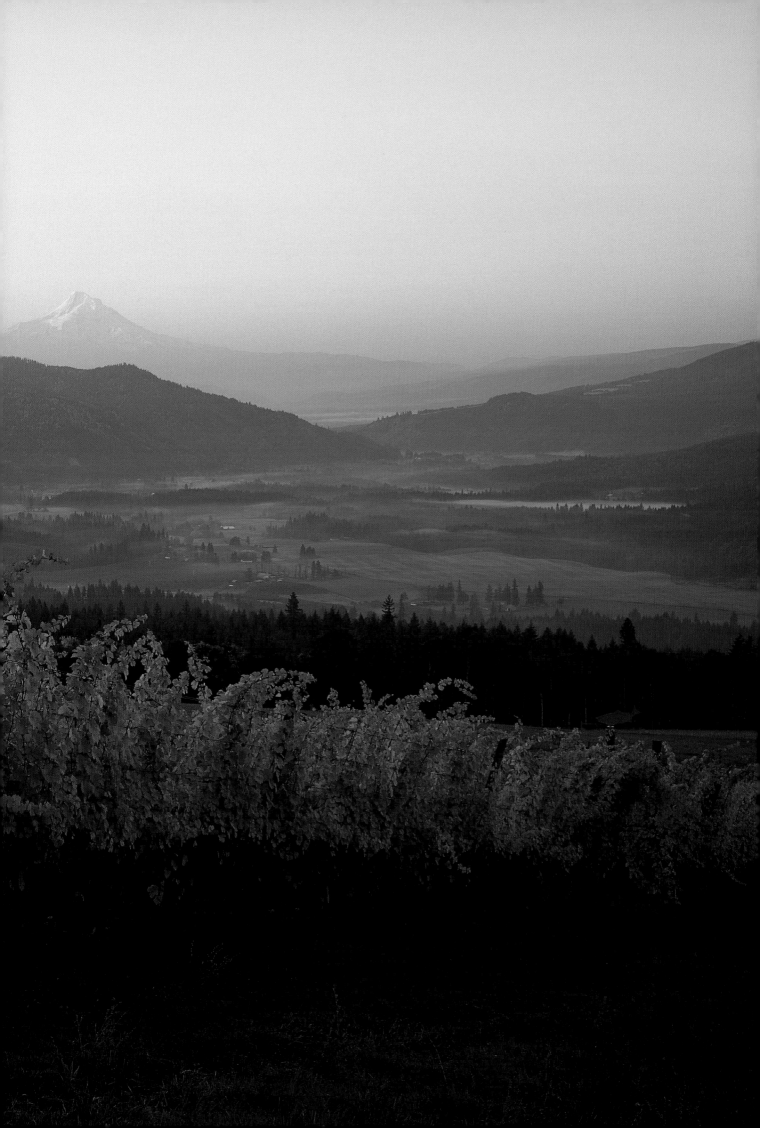

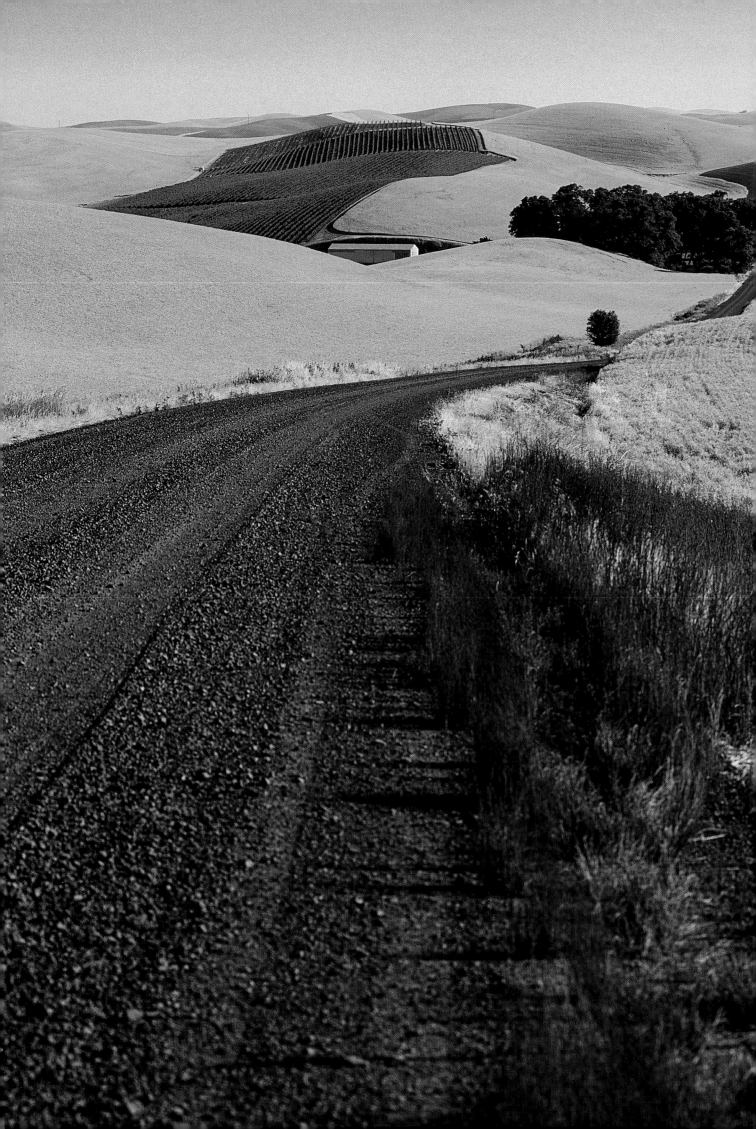

Prologue

There is a grassy knoll just west of Walla Walla, Washington. *Wa-i-lat-pu* the Indians called it, "place of the rye grass," named for the tall prairie grasses that once covered the Walla Walla Valley, and indeed, most of the Columbia River drainage. If you walk the meandering trail to the top of the knoll, you will take in the grandeur of this land—the valley floors shamrock green and bountiful in spring and summer, dry and dusty in late summer and fall, hoary and hard in winter. Long ago this place witnessed the daily rhythms of Native life. Today it is at the center of some of the world's finest vineyards and wineries. Along with the Puget Sound area far to the west, this is Washington Wine Country.

Hills to the north of the knoll display ridges running east to west—ancient wrinkles formed by cooling lava, the valleys covered with silt and rocks left by prehistoric floods. As the seasons pass, these ridges turn from the palest of fuzzy greens to soft shades of fawn, to lavender, to baked sienna, to bleak. And back again. Year after year. In summer some are dotted with the gold of rolling wheat fields or, more recently, the deep emerald of flourishing vineyards.

Wherever you go in the Columbia Basin the landscape repeats itself. In some places you will stand in sand and sagebrush, in others on a landscape of rocks the size of softballs. In some locations you will see the far-off tips of volcanic mountains—Hood, Adams, Rainier—or the huge Columbia River bringing abundance to what would otherwise be a desert. After a hot day the air will cool at twilight. The grapevines will heave grateful sighs and resuscitate themselves.

Spirits dwell here. You can hear them in the lapping of the river, in the soft evening rustle of the vineyards. The ancient people hunt and spear fish near where vineyards now flourish; white settlers come and leave and come again. W. B. Bridgman is spotted occasionally walking through his vineyards at Snipes Mountain near Sunnyside, while E. F. Blaine keeps watch over what was once the old Stone House Winery in Grandview. Andre Tchelistcheff nods his approval at the Cold Creek Vineyard that now bears his name. In Seattle, Lloyd Woodburne and Phil Church raise a glass to each other.

This is the story of Washington Wine Country—the land, the people, the wines.

> Spirits dwell here.
> You can hear them in the lapping of the river, in the soft evening rustle of the vineyards.

Left: In years past, the pesticides used on wheat made it impossible for vineyards and wheat fields to coexist. As Eastern Washington farmers learned the value of winegrapes as a crop, they modified pesticide use. Today, some wheat farmers also grow winegrapes, and it is not uncommon to see the two planted side by side.

As the seasons pass, these ridges turn
from the palest of fuzzy greens to soft shades of fawn,
to lavender, to baked sienna, to bleak. And back again.

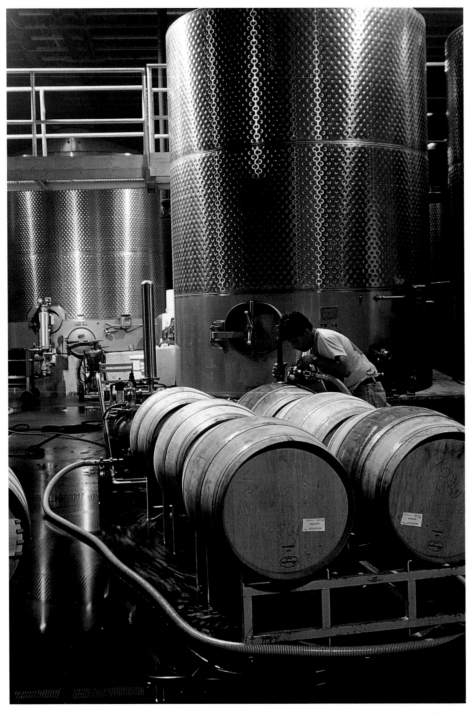

Above: Transferring wine from fermentation tanks into barrels for aging, as seen at Hedges Cellars, is just one of the less-than-romantic but important jobs in transforming grapes into great wines. *Right:* Winter visits Stimson Lane's Canoe Ridge Estate vineyard. A high, south-facing ridge overlooking the Columbia River, Canoe Ridge is one of the more protected vineyard sites in the Columbia Valley. Several hundred acres of vineyard are now planted here.

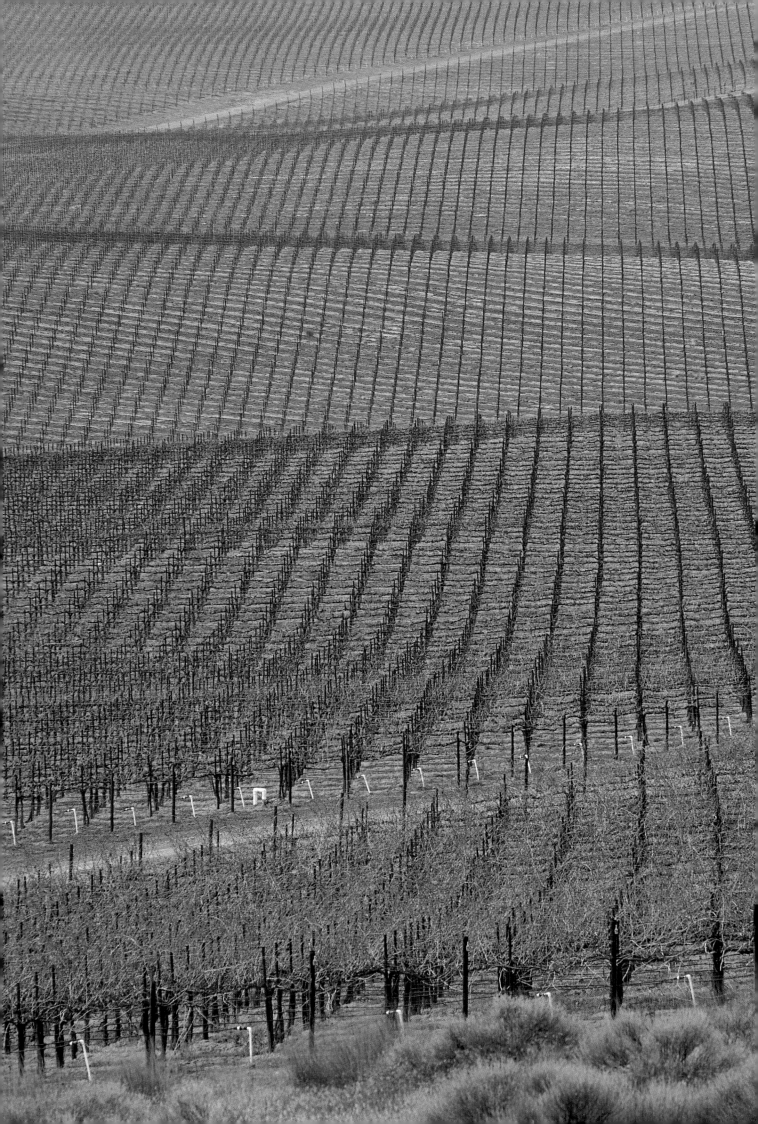

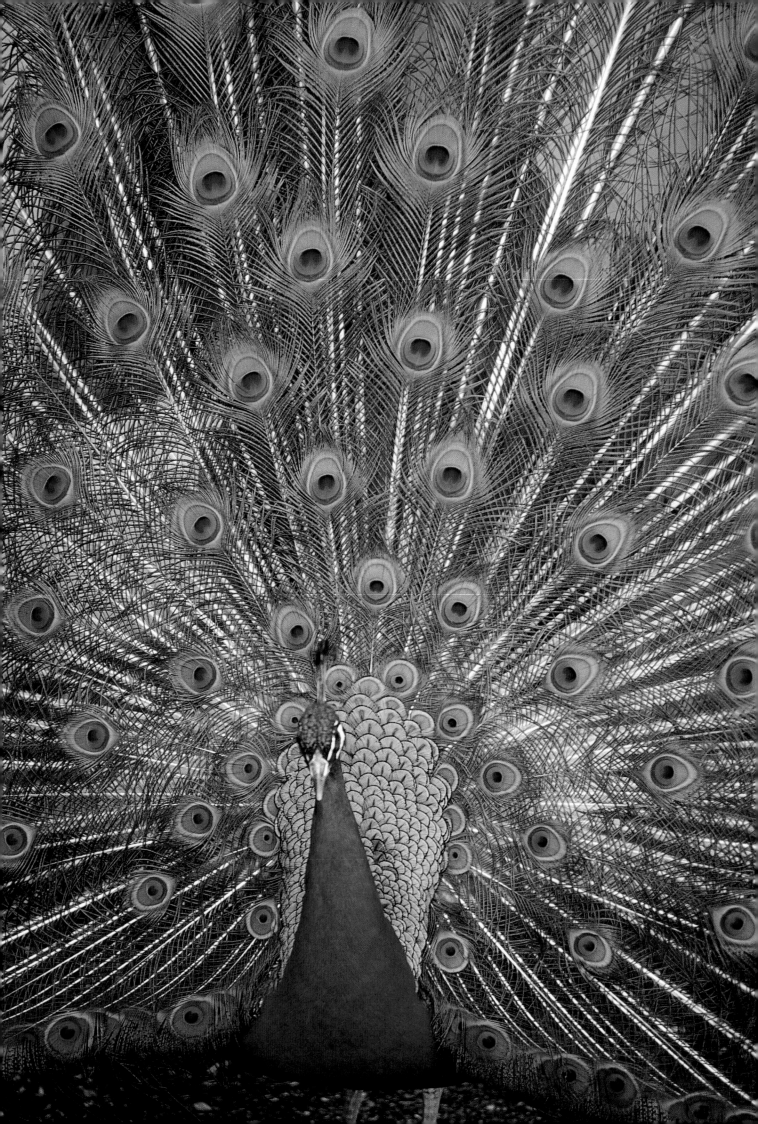

"Since I came to Washington, it has changed from a white-wine state to a red-wine state."

—Steve Burns

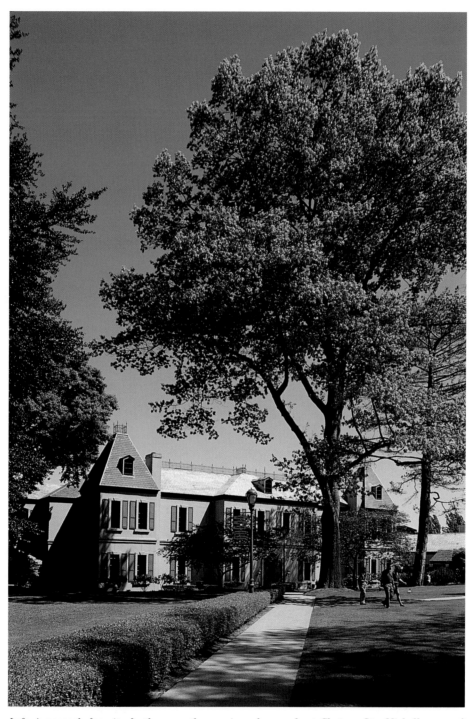

Left: A peacock fans its feathers on the manicured grounds at Chateau Ste. Michelle, one of Washington's major tourist attractions. *Above:* Shown in its full summer glory, the French-style Chateau Ste. Michelle, built in 1976 in Woodinville, is not only a huge working winery, but also the corporate headquarters for Stimson Lane Vineyards & Estates, which owns three Washington and two Napa Valley wineries and several thousand acres of premium vineyards.

"Winemaking is a work in progress.
Nothing is ever static."
—David Lake

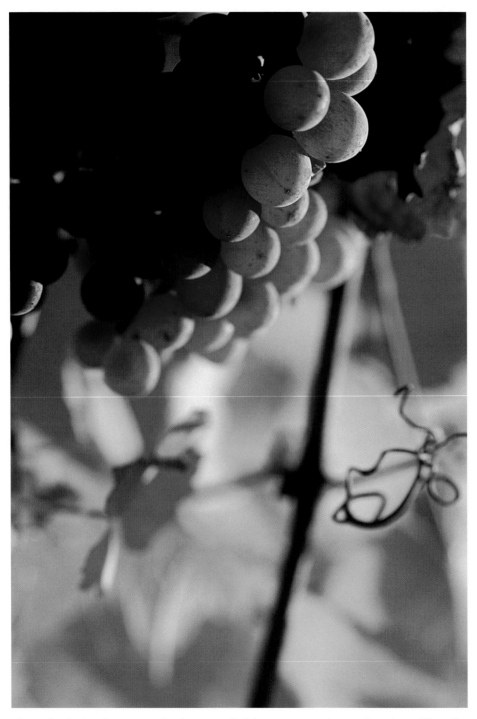

Above: Gewürztraminer grapes develop a wonderful rosy, coppery hue as they ripen. When the grapes are pressed, the skins are quickly removed so that the resulting wine is a pale, clear yellow with lovely aromas and flavors of crushed rose petals and spices. *Right:* At the tiny Chinook Winery in Prosser, owners Clay Mackey and Kay Simon labor side by side as they have since they married and released their first wines in 1984.

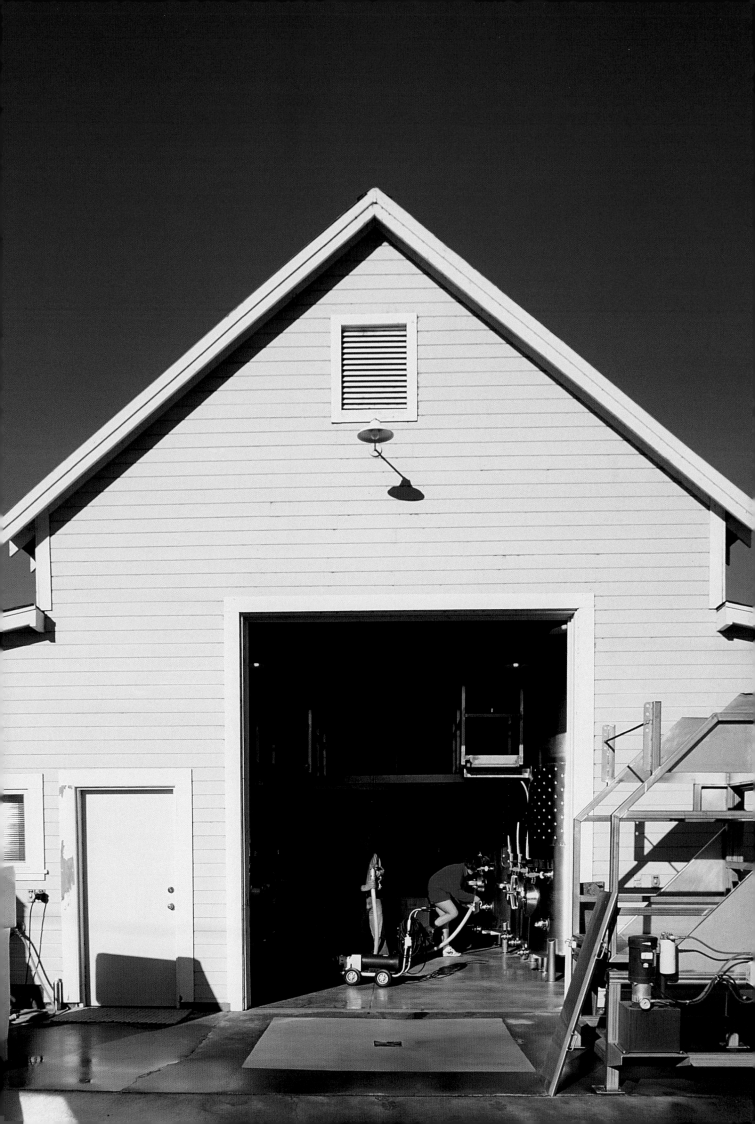

Charles

Washington

Sauterne

ST. CHARLES WINERY

U. S. BONDED WINERY No. 1, 15TH DISTRICT

GRAPEVIEW, WASHINGTON

3 0

TAX PAID BY STAMPS AFFIXED TO CASE AND CANCELLED

Washington Wine:
The Early Years

Washington state's lasting love affair with European winegrape varieties can be traced back to the English-born residents of Fort Vancouver, who brought their taste for wines with them to the New World.

The Hudson's Bay Company established plantings in 1825 at this fort along the Columbia River in southwestern Washington. These would have been the grapes the people there knew best, *Vitis vinifera*, the basic European winegrape species that encompasses the many varieties that we enjoy today. From the vines grown from seed, people at the fort harvested grapes, and it is believed they eventually made wine.

During the same era, French trappers and fur traders may have planted *vinifera* grapes in the Walla Walla Valley, far to the eastern side of the land that was to become Washington state. And up in the northeastern corner of Washington, a few plantings went in at Fort Colvile.

Other than these modest efforts, there was little grape propagation in the Northwest until the mid-1800s, when nurseries were established in the Puget Sound area and Oregon's Willamette Valley. Beginning in 1859 Eastern Washington saw an influx of settlers, many of European descent, and with them came their wines.

The new settlers sparked a wine industry in the Walla Walla Valley that blossomed for more than two decades. A. B. Roberts brought grape stock from the Willamette Valley and imported dozens of varieties from France. Italian immigrant Frank Orselli made wine in Walla Walla and sold it out of his California Bakery. Other winegrowers settled in the area, growing such popular European grape varieties as Flame Tokay, Sweetwater, Black Hamburg, and Black Prince.

In 1883 a winter freeze with temperatures more than twenty degrees below zero devastated the valley's infant wine industry. At the same time a combination of factors lured newcomers to other parts of the Northwest, and Walla Walla's economy flagged. California's wine industry matured during this period, but in Walla Walla it simply vanished.

Meanwhile in the Yakima Valley, German immigrant Anthony Herke homesteaded at Tampico and, in 1871, planted a vineyard that probably included

Left: This sauterne from the St. Charles Winery is not dated, but is believed to have been produced in 1933, the year Prohibition was repealed. Located on Stretch Island, St. Charles remained in business until 1965. *Overleaf:* Diversified farming characterizes the rolling landscape of more than one million irrigated acres in the Columbia Valley. While vinifera vineyards account for only about 30,000 acres, there is potential for up to 100,000 acres of winegrapes, depending on water-use allocation.

Chris Camarda
Andrew Will, Vashon Island

When Chris Camarda and his wife, Anne, made Andrew Will's first commercial wines in 1989, Chris already was a veteran of the University of Washington, the Vietnam War, and some top Seattle restaurants, including a stint as general manager of Il Bistro in the Pike Place Market. By the time this self-taught winemaker got into the wine business, "I knew the people, and I knew what I was getting into."

Chris and Anne started the winery in Seattle, naming it for their son Will and nephew Andrew. Concentrating on single-vineyard Cabernet Sauvignon and Merlot, their first wines, released in 1991, were an immediate success. By 1994 they had moved the winery to their home on nearby Vashon Island, where 95 percent of their yearly production of about 4,000 cases is red wine.

Chris says that in his journey as a winemaker, "My whole idea toward wines has changed." Today his wines are softer and more approachable, with slightly lower acidity. In addition to Cabernet and Merlot, he is working with Cabernet Franc, which the Camardas grow at their small vineyard in the Walla Walla Valley. He is also making a small amount of Sangiovese, which he believes has great potential in Washington.

Whites are made under Andrew Will's second label, Cuvée Lulu, named for a niece. They include Chenin Blanc, Chardonnay, and Pinot Gris. A small amount of Syrah also is made under the Cuvée Lulu label.

ANDREW WILL

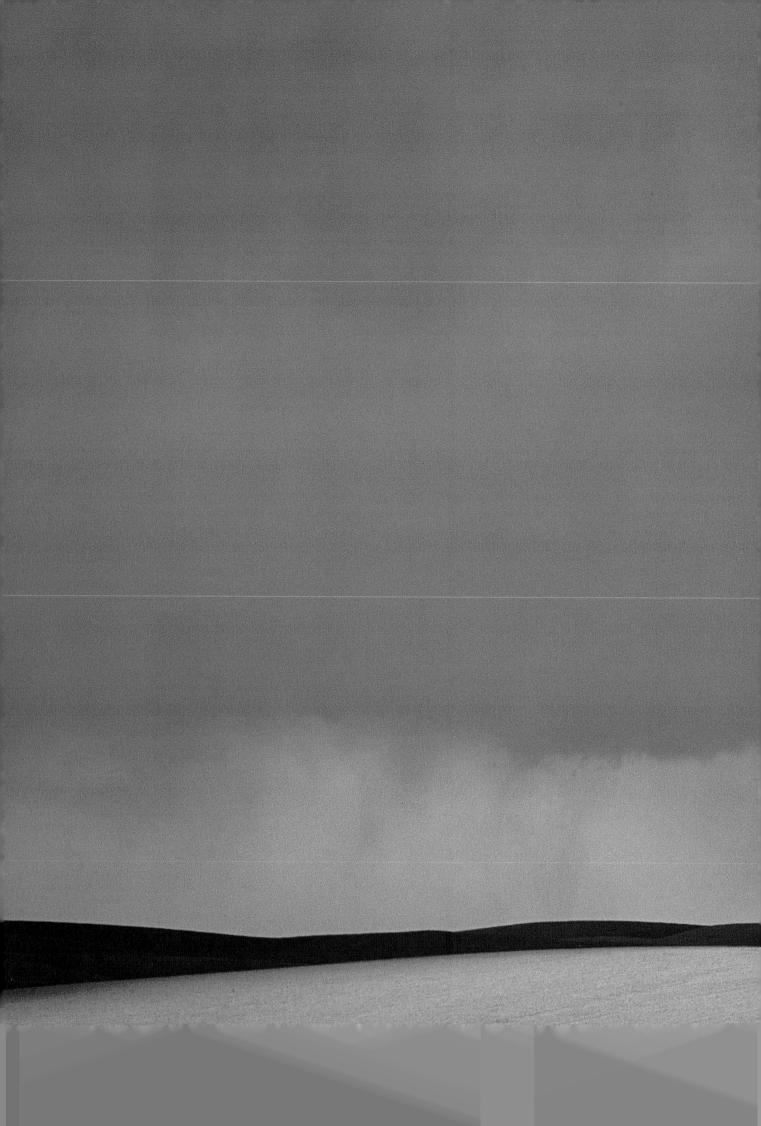

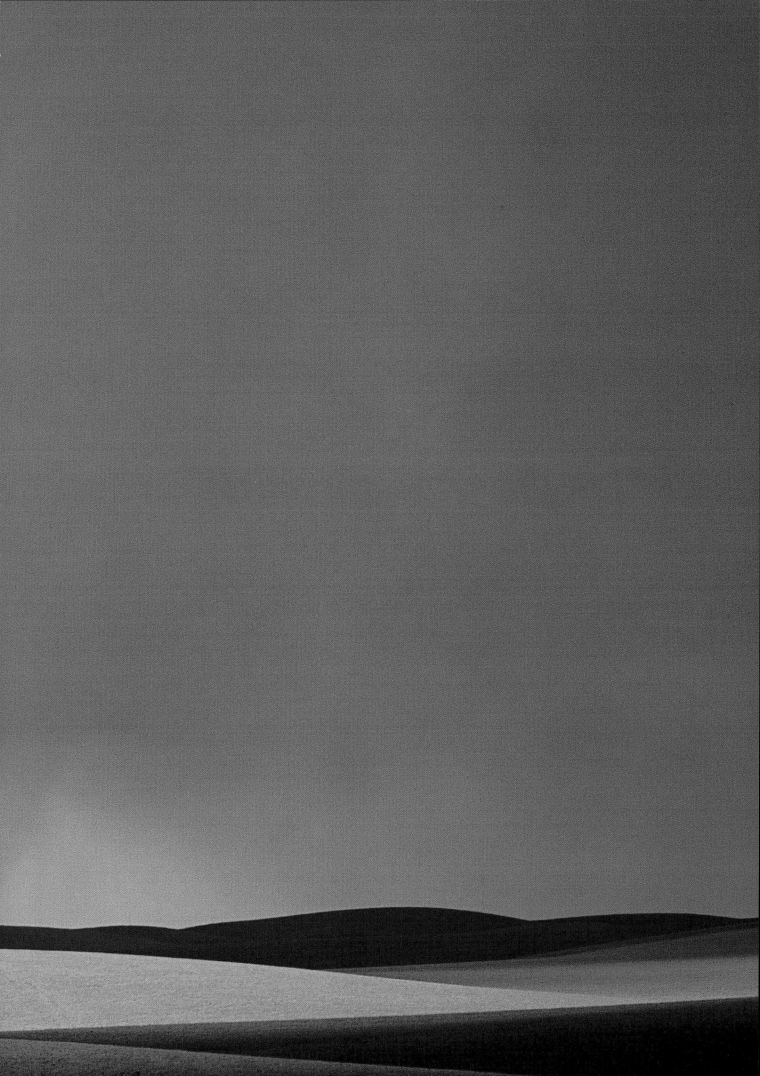

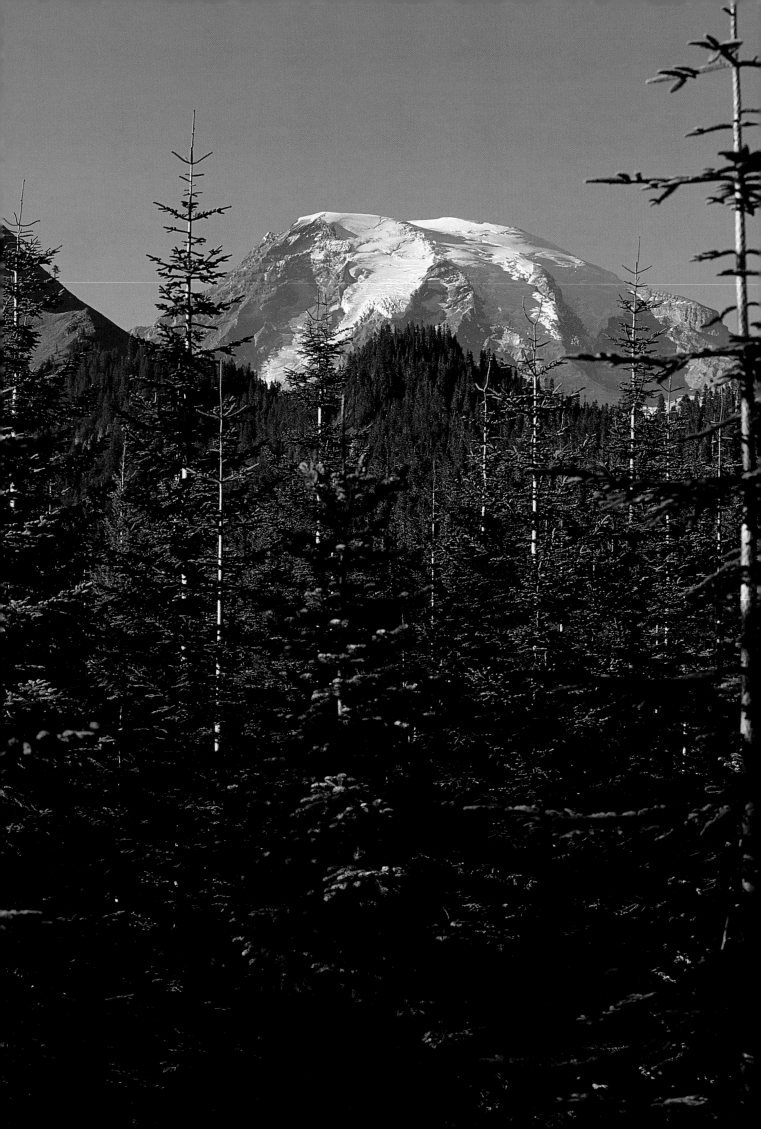

Lemberger and Riesling. Just a few miles away, near Union Gap, the Schanno family also planted grapevines.

In the Wenatchee area beginning in 1873, John Galler and other settlers grew grapes and made wine.

Western Washington

On the other side of the Cascade Mountains, in Western Washington, Lambert Evans settled on an island in the southern part of Puget Sound in the early 1870s. This Florida native and Civil War veteran chose a pleasant, south-facing hillside near the water and planted apples and grapes, which he sold in nearby Olympia. The island, now named Stretch Island, was known for many years as Evans Island.

Less of a survivalist and more of an entrepreneur than Evans, Adam Eckert arrived on the island in 1889. He liked what he saw, purchased forty acres from Evans, and moved his family out from Auburn, New York. Eckert also planted apples and grapes, but he much preferred the grapes and introduced to the island a variety called Island Belle.

Researchers have since determined that this variety is the same as Campbell Early, a cross between a native North American *Vitis labrusca* grape variety and a European *Vitis vinifera*. Hybrids such as Campbell Early are ideally suited to Puget Sound's cool, damp growing conditions because they ripen early, yield generously, and are mildew resistant.

Until Prohibition, the grape was used as a table grape and for juice. When Prohibition became law in 1917, Island Belle/Campbell Early quickly gained popularity with home winemakers, who were allowed by law to make table wine for home consumption.

After the 1933 repeal of Prohibition, wineries came under state regulation and were required to be licensed, or bonded. In December 1933, St. Charles Winery on Stretch Island became Washington's first bonded winery.

Real estate agent Charles Somers was the owner of St. Charles, situated on the former Lambert Evans farm. The St. Charles winemaker was Erich Steenborg, a young German trained in his country. While Steenborg was educated in the making of vinifera wines, the basic European varieties, he made the best wines he could with the grapes on hand.

Puget Sound growers learned that native varieties could survive where European grapes could not. As in Eastern Washington, it was a matter of climate—but on the western side of the Cascade Mountains, the problem wasn't cold winters, but rather too much rain as the grapes tried to bloom in spring, not enough heat during the summer growing season, and relatively high

Left: The spectacular Cascade Mountain Range, with Mt. Rainier in the background, forms a natural partition between Western Washington's maritime climate and the irrigated deserts of Eastern Washington wine country. During harvest, winegrapes are transported from the east side to the west side of the state under cover of darkness to keep them from being overheated as they travel to Western Washington wineries for processing.

Rob Griffin
Barnard Griffin, Richland

One of the Washington wine industry's first modern-day winemakers, Rob Griffin grew up in California and attended the University of California at Davis, where he graduated with honors in 1975 in enology/viticulture.

Griffin has worked all but eighteen months of his career in Washington. Following a brief stint as chemist for Buena Vista Winery in Sonoma, he was hired by Preston Wine Cellars in Pasco in 1977. While there, his wines won national and international acclaim. In August 1984 he was hired as winemaker for The Hogue Cellars, then in its third year of production.

During his tenure at The Hogue Cellars, Griffin and his wife, Deborah Barnard, started their own small winery, Barnard Griffin. Griffin made his wine in The Hogue's facility, building their large brand as well as his small one. He was general manager of The Hogue Cellars when he left in 1991.

Barnard Griffin grew slowly. "We did it all ourselves," Griffin says proudly. In 1996 the couple took out their first loan to build their current facility in Richland. The winery has grown from very tiny to its current level of 30,000 cases a year, with plans to top production at around 40,000 cases.

Barnard Griffin is known for its Cabernet Sauvignon, Merlot, Fumé Blanc, and Chardonnay. Griffin also produces about 1,000 cases a year of Semillon, one of the best in Washington. He dabbles in Zinfandel grown at Hell's Gate Vineyard on the Columbia River near Maryhill and has joined the growing number of Washington winemakers producing Syrah. "In this climate it makes pretty exciting wine," he says.

The winery has no vineyards of its own but instead has nurtured long-term contracts with several of Washington's best-known grape growers. The growers are distributed throughout the Columbia Valley. "I'm a big believer in blending for complexity," Griffin says.

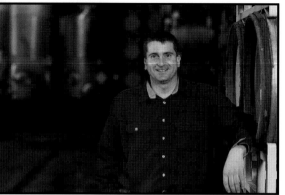

John Abbott
Canoe Ridge Vineyard, Walla Walla

At John Abbott's childhood home in Bandon, Oregon, wine was served on special occasions. "I knew it was a special thing," he remembers. But he didn't know winemaking would become his vocation until much later. After three years in Oregon State University's veterinary medicine program, Abbott transferred into OSU's horticulture program. He participated in sensory evaluations in the food science department on the side.

Some of the evaluations involved Oregon wines, and as a result Abbott's career focus became clearer. He took viticulture and enology courses at Fresno State University and earned a horticulture degree. His first winery job was at Napa Valley's Pine Ridge Winery in 1990.

When he moved to nearby Acacia Winery as its enologist, Abbott learned about Canoe Ridge Vineyard, which at the time involved the Chalone Wine Group (Acacia's owners) and a group of Washington-based investors.

"I'd always wanted to return to the Northwest," he says. By early 1993, Abbott was at Canoe Ridge as winemaker. After Canoe Ridge's first crush, he convinced Chalone that it needed its own facility. A winery was built in a historic building in Walla Walla, several miles from the vineyard.

Abbott's focus is on reds—primarily Merlot. As the Cabernet Sauvignon matures, Canoe Ridge will make more of that as well.

Abbott sees promise for Syrah, but is not interested in doing it himself. "I want to focus on what we do well here, and perhaps showcase some blocks or do vineyard-designated reds later on," he says. The winery uses grapes from other growers in the region in addition to those from its own Canoe Ridge Vineyard.

humidity that encouraged the mildew to which vinifera grapes are particularly susceptible.

By 1938, Washington had forty-two wineries, most of them small, family-run ventures. The larger, more important wineries were in Western Washington, in the Puget Sound area that included Seattle and offered the best market for wine. But as the state edged toward developing a modern wine industry, it was Eastern Washington that would become ascendant.

Eastern Washington

By the early 1900s, fans of the European grapes were tending modest plantings in Eastern Washington that included such varieties as Black Cornichon, Black Hamburg, Palomino (also called Sweetwater), Riesling, Mission, and Muscat. Also on the vine were Carignane, Malaga, Sauvignon Blanc, Semillon, and Zinfandel grapes. The imports benefited from the long, hot summer days, but they had to contend with the inevitable winters when temperatures plunged below zero degrees

Fahrenheit for many days. Vineyards planted with cold-sensitive European grapes were often wiped out.

Growers devoted to the European varieties would start all over again—but they didn't pin all their hopes on these grapes. Growers found that the native North American species *Vitis labrusca* fared much better in Eastern Washington's harsh winters. The labruscas could be made into tolerable wines, and they also were desirable as table and juice grapes. Among the many labrusca varieties planted in Eastern Washington during the late 1800s and early 1900s were Concord, Niagara, Delaware, Brighton, and Diamond.

A flurry of grape-growing activity in Eastern Washington was made possible in the early 1900s as irrigation systems transformed deserts in the Yakima Valley and the Tri-Cities region of Richland, Kennewick, and Pasco into valuable farmland. Most significant to the

Above: DeLille Cellars' vineyard-designated Harrison Hill wine comes from thirty-seven-year-old vines growing on the property originally planted to winegrapes by W. B. Bridgman. *Right:* An aerial view of the Yakima Valley gives perspective to the variety of crops grown here, including asparagus, alfalfa, hops, onions and other row crops, apples, Concord grapes, and, of course, winegrapes.

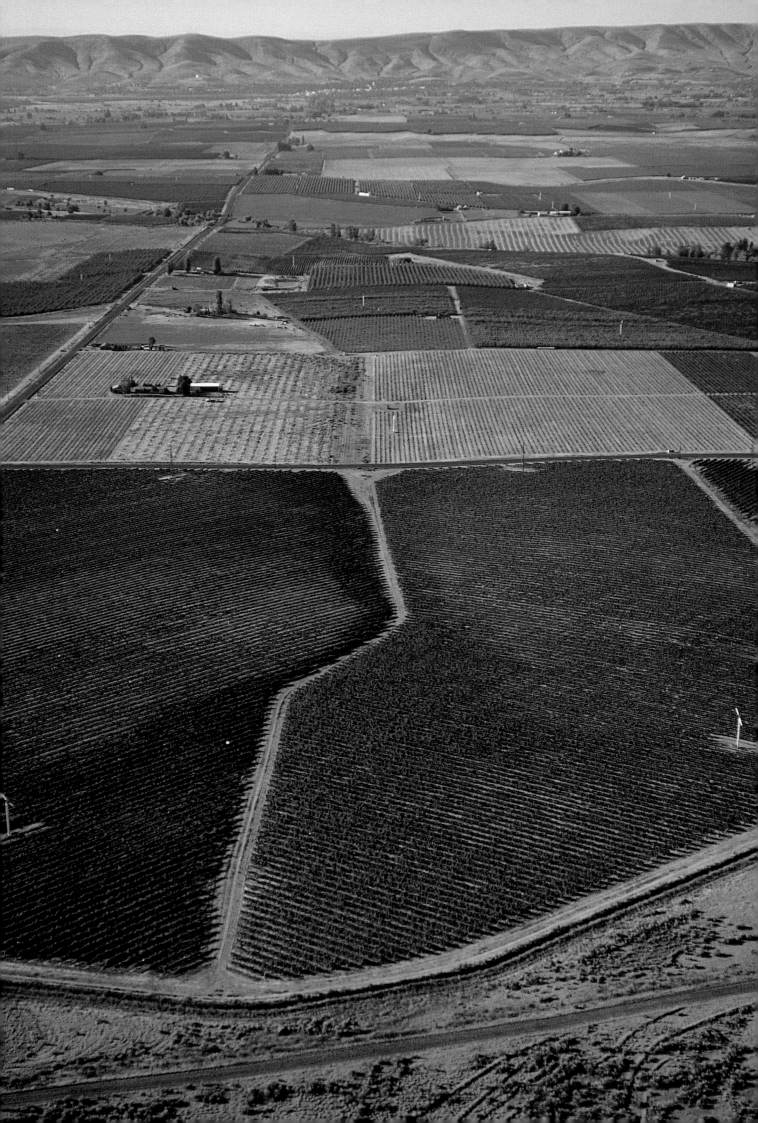

Mike Scott
Caterina Winery, Spokane

development of this grape industry were W. B. Bridgman and E. F. Blaine.

Seattle attorney E. F. Blaine came to the Yakima Valley in 1902, settling in Grandview. He managed an irrigation company and was among those who foresaw a lucrative wine and grape industry in the valley. Blaine planted winegrapes near Grandview and established Stone House Winery. With Canadian Paul Charvet as winemaker, Stone House between 1907 and 1910 produced wines from Zinfandel, Concord, and other grape varieties.

Bridgman arrived in Sunnyside as a young attorney, also in 1902. He drafted some of the state's first irrigation laws, managed a small irrigation company, and eventually became a grape grower. Bridgman planted table grapes on his Harrison Hill farmland in 1914 and began another planting that included several varieties of winegrapes on adjacent Snipes Mountain in 1917. Since home winemaking was legal during Prohibition, there was good demand for Bridgman's table grapes.

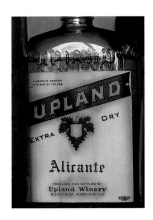

During this time, Bridgman became an expert in grape varieties and propagation.

By 1933 when Washington became the twenty-fourth state to vote for repeal of Prohibition, Bridgman had 165 acres planted in winegrapes and was ready to open a winery. His Upland Winery in Sunnyside received Washington bond No. 13. In autumn of 1934, Upland produced 7,000 gallons of wine made from grapes grown at Bridgman's vineyard.

Bridgman eventually hired winemaker Erich Steenborg away from Western Washington. Upland was the first Washington winery to produce a dry wine from the Riesling grape. At Upland, Steenborg also made Zinfandel, Semillon, and Cabernet Sauvignon. Together Bridgman and Steenborg laid the groundwork for Washington's modern wine industry.

How does a nice young man from Cambridge, England, end up in Spokane, Washington? "It is a lurid tale involving a woman," according to Mike Scott, winemaker at Caterina Winery. Scott says he found himself in Spokane in 1980 with no woman and lots of bills. So he took a job at Spokane's first winery, Worden Winery, pouring wine in the tasting room.

"I interviewed with Mike Conway, who was Worden's first winemaker, and we hit it off," he explains. "I found the industry absolutely fascinating. I learned whatever I could from whomever I could." In 1985 when Conway needed an assistant winemaker at his own winery, Latah Creek, he hired Scott.

In 1990, local entertainment mogul Steve Livingston opened a winery and hired Scott as associate winemaker. While at Livingston, Scott had the opportunity to experiment and to hone his own style. Then in 1993 Livingston decided to leave the wine business. Very much wanting to keep his job, Scott put together a five-year plan and, aided by an attorney friend, went looking for investors to keep the business going.

A family of investors formed the Caterina Trust, named for the investors' great-grandmother. The winery, owned by the trust, relocated to a charming old dairy near Spokane's downtown Riverfront Park. Caterina produces about 7,000 cases of wine yearly, including Chardonnay, Sauvignon Blanc, Merlot, and Cabernet Sauvignon.

Left: Wheat farmer Dean Derby epitomizes the people whose skills and tenacity turned the Columbia Valley from desert to a bread basket. Derby and his wife, Shari, own Spring Valley Vineyard, planted in 1994 amid the wheat fields. *Above:* The Upland Winery, established in 1934 in Sunnyside by W. B. Bridgman, was one of the first post-Prohibition Washington wineries to make wines from European grape varieties.

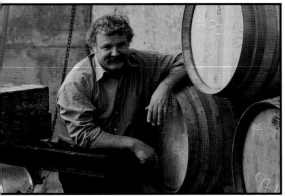

Peter Dow
Cavatappi Winery, Kirkland

Peter Dow is the kind of person who follows his nose. It leads him to interesting places. For example, while he is neither a chef nor Italian, he opened his own Italian restaurant, Café Juanita, in Kirkland, near Seattle, in 1976 and has enjoyed comfortable success.

Following a visit to Italy, where he dined in restaurants that produced their own table wines, he decided to do the same. The idea was fraught with bureaucratic hoop-jumping, but as Dow once explained, "I like obstacles." He jumped through the hoops, and Cavatappi (Italian for corkscrew) Winery celebrated its first crush in the restaurant's basement in autumn of 1984.

The first Cavatappi wine was a Sauvignon Blanc made with grapes obtained from Eastern Washington's Sagemoor Vineyards. But following his nose again, Dow decided to make wine from the Nebbiolo grape native to Italy's Piedmont.

In 1985 he and some friends planted seven hundred tiny Nebbiolo vines at Mike Sauer's Red Willow Vineyard in the eastern Yakima Valley. For good luck they buried empty bottles of prized Italian Barolos alongside the vines. Only three vines died that first year.

Dow spent two months in Italy in 1986, working crush with renowned Piedmont winemaker Angelo Gaya. In 1987 he harvested Washington's first Nebbiolo grapes and christened his new red wine Maddalena.

The winery is still in Café Juanita's basement. It is a low-tech affair of demijohns in huge baskets and things held together with duct tape. Cavatappi has a homespun appeal not unlike its owner. It produces about 900 cases yearly, and its delicious wines are found only at Café Juanita and a few outlets in the Seattle area.

Another key scene in the Washington wine story opened in 1934, when the National Wine Company of Grandview and Pomerelle Winery of Seattle were bonded. National Wine Company, also known as Nawico, made sweet, low-alcohol table wines; Pomerelle made fruit and berry wines. Pomerelle purchased Nawico before World War II, but they maintained separate identities until 1954, when they merged to become American Wine Growers—forerunner of Ste. Michelle Vintners.

Brutally cold winters in 1949 and 1950 killed most of the vinifera plantings of Bridgman and other growers. Upland Winery struggled. In 1960, at the age of 82, Bridgman sold Upland (which became the short-lived Santa Rosa Winery). Bridgman died in 1968, but his dream for an industry based on classic European-style wines lived on.

As Bridgman and others pioneered the culture of European varieties, the native Concord grape kept its place as the principal moneymaker. The cultivation of Concords that got underway in the Yakima Valley in

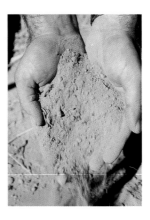

1904 was successful enough that by 1913, Church Grape Juice Company in Kennewick was producing the state's first unsweetened Concord grape juice. Over the years the native Concord staked a long-term claim to be *the* Washington grape.

In 1949, E&J Gallo bought 4,000 tons of Eastern Washington Concords for its California winery, and the grapes soon became a mainstay of Gallo's Cold Duck sparkling wine. Four years later Gallo contracted for 30,000 gallons of Concord grape juice—a total that paled against the volumes of juice the company ordered in later years for use in its Cold Duck and other low-end or fortified wines.

As growers in Eastern Washington put more and more acreage into Concords, scientific work was taking place that would transform the state's grape industry. With the encouragement of Bridgman, horticulturist Walter Clore had begun planting vinifera winegrapes at the state's Irrigation Branch Experiment Station at Prosser.

Above: The soil in the Columbia Basin was likely deposited from devastating floods about 12,000 years ago. *Right:* Bare-root, one-year-old grapevines await spring planting. Cuttings are rooted and cultivated in nurseries for a year prior to planting.

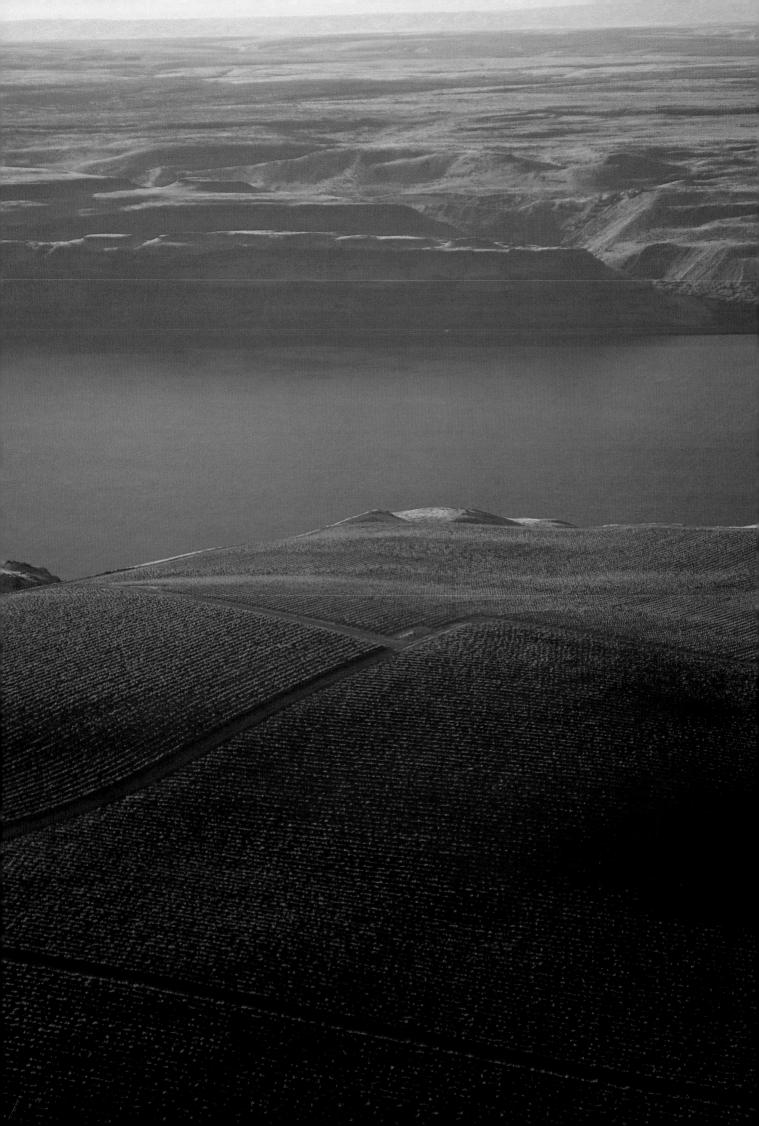

The Wine Regions of Washington

Christophe Baron
Cayuse Vineyards, Walla Walla

Washington is home to four principal wine regions and a growing number of sub-regions. The four regions are officially designated by the federal government as viticultural areas. These regions also are known as appellations—from the French, designating a geographical area in which winegrapes are produced.

The wine regions, or appellations, of the state are the Columbia Valley (in Eastern Washington), the Yakima Valley (which is within the bounds of the Columbia Valley), the Walla Walla Valley (also within the Columbia Valley), and Puget Sound (in Western Washington).

Columbia Valley

The Columbia Valley, with more than a million irrigated acres, produces over 99 percent of Washington's winegrapes. This immense region extends from the prehistoric Okanogan Lobe in northern Washington all the way south into Oregon. The lobe, created by the continental ice sheet as it advanced and retracted, is a hilly protrusion that runs from Canada into Washington, forming a natural northern boundary to the Columbia Valley.

The Cascade Mountains mark the region's western boundary. The valley's natural eastern boundary is the Palouse Formation, a large and fertile plateau created during interglacial warming periods when huge dust storms blew clouds of volcanic ash and sediment east across the basin.

Primary grape-growing lands within the region, in addition to the Yakima and Walla Walla Valleys, include the Pasco Basin surrounding the Tri-Cities area and the Quincy Basin to its north. The Columbia River runs south through these basins before turning westward to form the Washington-Oregon border. The northern bank of the Columbia River forms another major grape-growing area, with vineyards protected from winter destruction by south-facing slopes and by the warming influence of the huge water mass of the river.

Why is the Columbia Valley so well suited to winegrape growing? A prime reason is its location between the 46th and 48th parallels, the same latitudes that abut France's Bordeaux region and that include both the Loire and Burgundy regions of France. These latitudes

Christophe Baron's family owns a small Champagne house in the Marne Valley of France, so he grew up around fine wines. He studied viticulture and enology both in Champagne and Burgundy, then spent a year working with Eric and Janet Rindal at Waterbrook Winery in the Walla Walla Valley. He also worked the 1994 harvest at Adelsheim Vineyard in Oregon's Willamette Valley.

He became a flying winemaker for a British firm, making wines for his employer in Romania, New Zealand, and Australia. In 1996 he purchased land in the Walla Walla Valley, a ripped-out orchard covered with smooth fist to softball-size cobblestones that reminded him of Chateauneuf-du-Pape—the winemaking region in southern France known for its deep-colored intensely concentrated wine.

During 1997 and 1998, Baron planted his first vineyard—22 acres. He made Cayuse Vineyards' first wines in 1997—a Columbia Valley Syrah and a Bordeaux blend called Camaspelo. When his vineyards are mature, he expects to produce between 4,000 and 5,000 cases of wine yearly, concentrating on Syrah, Cabernet Sauvignon and a Bordeaux blend.

Baron considers himself a vigneron—one who both cultivates grapes and produces wine—and not simply a winemaker: "My goal is to spend as much time as possible in the vineyards. When you grow great grapes, winemaking is done by itself."

And the name of the vineyard? French fur traders called the Walla Walla Valley's native people les cailloux, or "people of the stone," after the ancient river-bottom stone found there. The tribe later was called the Cayuse, also a name for the wild horses that grazed the foothills of the Wallowa Mountains. Baron's research reveals that Cayuse could be an offshoot of the original French name.

Left: Huge vineyards stretch for miles along the north bank of the Columbia River. The combination of south-facing slopes and the moderating influence of the river, even during the coldest of winters, provides a protected environment for cold-sensitive European grape varieties.

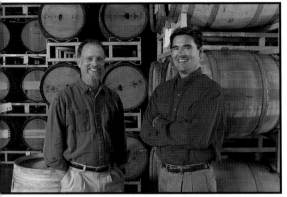

RON BUNNELL & ERIK OLSEN
Chateau Ste. Michelle, Woodinville

The departures of head winemaker Mike Januik and red winemaker Charlie Hoppes in 1999 left Chateau Ste. Michelle with large shoes to fill. To head white winemaking at the Woodinville facility, the company chose Erik Olsen, who has worked for Chateau Ste. Michelle since 1993. It was a natural choice since Olsen has been making Chateau Ste. Michelle's single vineyard white wines since the program was launched.

Olsen earned his masters degree in food science from Cornell University. His master's thesis on malolactic fermentation was considered a breakthrough for winemaking and has been widely reprinted in trade publications. Before coming to Washington, Olsen's experience included stints at Robert Mondavi Winery in Napa Valley and Simi Winery in Sonoma Valley.

Tapped as head red winemaker, Ron Bunnell oversees winemaking at the Chateau's River Ridge winery on Canoe Ridge. Bunnell earned a Master of Science degree from the University of California at Davis and an MBA from Sonoma State University. Bunnell worked previously at Kendall-Jackson, Beringer, and Chateau Souverain wineries in California. Based in Eastern Washington near the vineyards, he says, "My goal is to work with our viticulturists to establish a program of stewardship in the vineyards and continue that in the winery."

enjoy long daylight hours during the growing season—up to two hours more of light each day than the more southerly latitudes of the California winegrowing regions.

The Columbia River has a great moderating influence on air temperature. In winter, the water mass is more temperate than the ambient air, providing warmer temperatures along the river and thus protection from freezing for vinifera grapes. In summer, when daytime temperatures often go above 100 degrees Fahrenheit, the river cools the air. Temperatures drop an average of 40 degrees at night. This cooling allows ripening grapes to respirate, building desirable levels of natural acidity. The acidity in turn produces wines deliciously lively in their youth, with the ability to withstand considerable aging.

Another important factor is that the Columbia Valley is irrigated desert. The region averages only eight to eleven inches of rainfall a year—not nearly enough to grow healthy winegrapes. But growers have water from the river's huge irrigation projects, so they

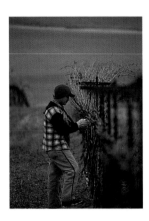

can decide how much water their plants receive and when they get it. If need be, the plants can be stressed to concentrate fruit flavors by withholding water at times. If they get too dry, just add water.

And the valley's well-drained soils are just right for grape growing. The strata of basalt, sand, and silt left by ancient volcanoes, windstorms, and repeated flooding for the most part are not too rich, whereas overly rich bottom soils encourage the growth of foliage at the expense of quality fruit. This region's soils provide a nearly ideal mix.

Harsh winters in the Columbia Valley are a fact of life that growers have had to deal with. Growers learned that grapevines fare better in winter if they are not weakened by overly heavy crops. So they began choosing their plant sites more carefully for

Above: Dressed for the chill, a worker prunes vines in winter at Canoe Ridge Vineyard. *Right:* A tiny Cabernet Sauvignon bud emerges in Eastern Washington's early spring. A natural for Washington, Cabernet is more winter hardy than most European grape varieties. It buds, blooms, and ripens relatively late, which increases its chances for a good crop and poses few problems since the region's dry, sunny autumns are conducive to late-ripening grapes.

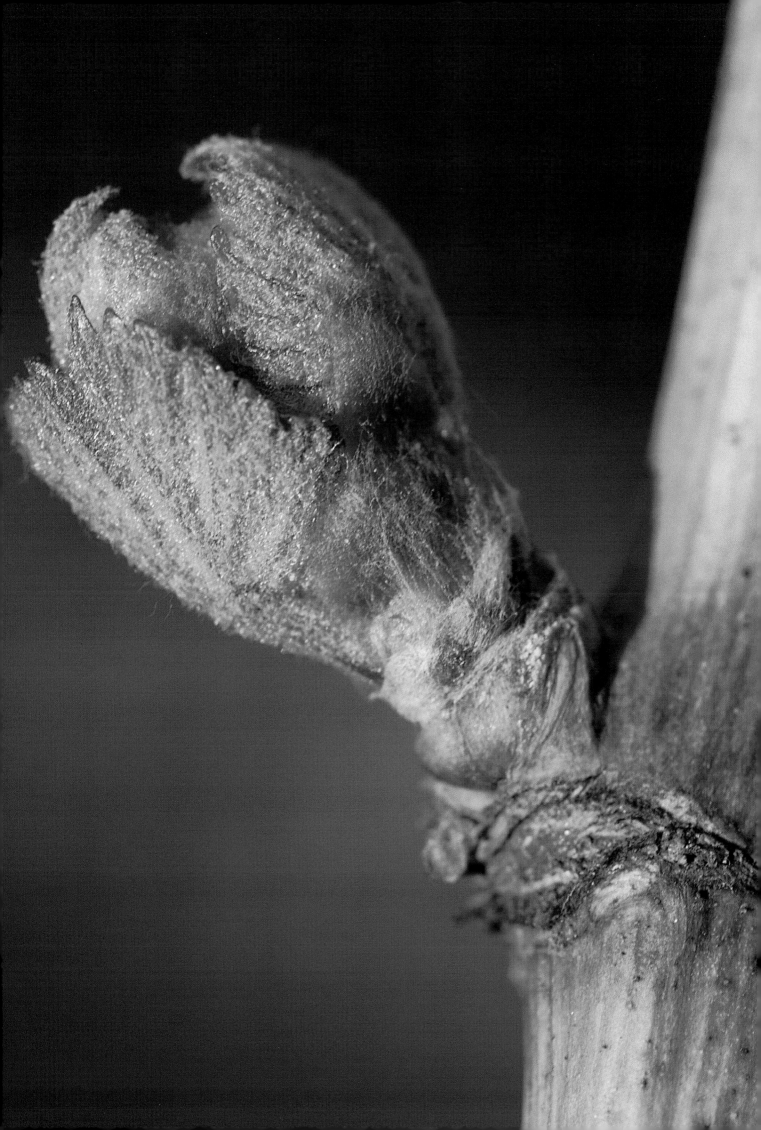

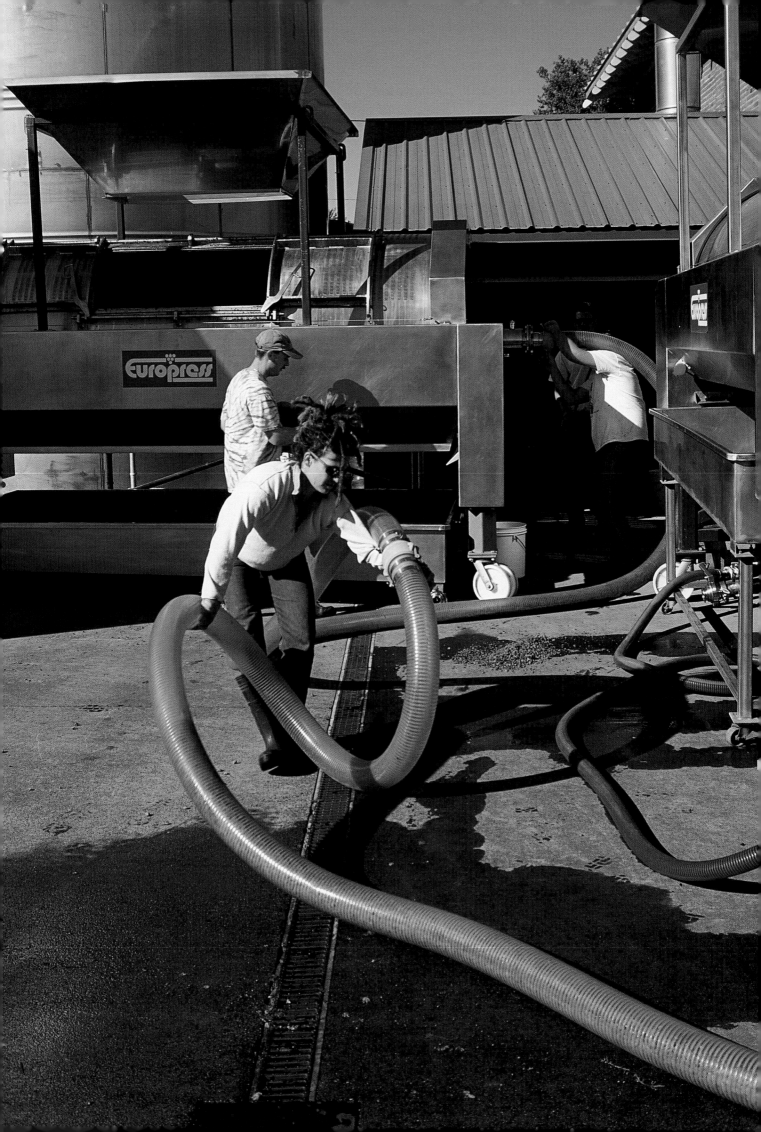

particular varieties. And over time, the Columbia Valley grew into a phenomenal producer of winegrapes, making Washington recognized internationally as a maker of premium *Vitis vinifera* wines.

Yakima Valley

It's appropriate that the eighty-mile-long Yakima Valley is shaped like the traditional horn of plenty, because it has grown into a land of bountiful farms since irrigation came to the region a century ago.

The valley is actually one of a number of ancient wrinkles formed in the land when a heavy basalt layer left by volcanoes cooled and sank. During a series of prehistoric floods, large temporary lakes formed. Lake Lewis covered what is now the Yakima and Walla Walla Valleys and the Quincy and Pasco Basins. Throughout the times of flooding, Lake Lewis repeatedly filled and emptied. Each flood brought with it fine silt that left the valley and basin floors layered with the soils that have proven so good for grape growing.

Bounded to the south by the Horse Heaven Hills and to the north by Ahtanum Ridge and the Rattlesnake Hills, the Yakima Valley enjoys a more temperate climate than the larger Columbia Valley region of which it is a part. Within the sunny, irrigated valley are sites conducive to growing a variety of winegrapes.

In the 1980s, Yakima Valley was known principally for its white grapes—everything from the cooler-climate Riesling, Gewürztraminer, and Chenin Blanc to the more heat-loving Chardonnay, Sauvignon Blanc, and Semillon. Over the years, with the improving quality of Washington's Cabernet Sauvignon and Merlot, reds have begun to dominate.

The Yakima Valley is now home to the greatest concentration of vineyards and wineries in the state.

Walla Walla Valley

The Walla Walla Valley is a nearly closed basin stretching about thirty miles east to west across a valley

Left: Hoses, presses, yellow jackets, the sweet smell of ripe grapes—a flurry of activity is the hallmark of grape harvest at Canoe Ridge Winery in Walla Walla, and at all wineries during the yearly crush. *Above:* Harvesters bring in the grapes at Champoux Vineyard.

Kay Simon
Chinook Wines, Prosser

Two momentous events made 1984 a banner year for Kay Simon and Clay Mackey. In August of that year, they married each other and they released their first wines.

Simon is one of the Northwest's best-known enologists. She studied fermentation science and enology at the University of California at Davis and took a winemaking position at Chateau Ste. Michelle in 1977.

Mackey, whose experience is in the vineyard, grew up in the Napa Valley and worked summers for legendary winemaker Joe Heitz. He studied viticulture at U.C. Davis and managed vineyards in Napa Valley for several years before going to work for Chateau Ste. Michelle in 1979.

In creating Chinook Wines, the couple's goals were to do work they love and to make a living. They have succeeded. Modest production and excellent product assure the best quality, so the wines are always in demand. The small tasting room, in a renovated farmhouse, is charming and a joy to visit. Kay is at the helm of Chinook's winemaking, while Clay manages grape sources; they team up on marketing.

The winery is housed in a barn behind the tasting room, and things have changed very little since it opened. "We've tweaked our grape sources slightly," Simon says. "And we've upgraded equipment—the simple but important things." Fruit is handled gently, but mechanization has made the process more efficient.

In addition to Semillon, Sauvignon Blanc, Chardonnay, Cabernet Sauvignon, and Merlot, Chinook recently produced a dry Cabernet Franc Rosé. "I want to do more Cabernet Franc," says Simon. "And I want to do it as a red."

CHINOOK
YAKIMA VALLEY WINES

Doug Gore
Columbia Crest Winery, Paterson

Few people with twenty years at the same job are still excited by it, but Columbia Crest winemaker Doug Gore is one of the lucky ones. Now vice president of winemaking at Columbia Crest, Gore oversees production of more than a million cases of wine yearly. And he is steadfastly devoted to his role in Washington's wine industry.

"My philosophy has stayed the same," he says. "First you need good grapes, then good people and good equipment." Gore finds himself spending more time in the vineyards every year, and he says it pays off in the quality of the grapes. As for the people, "I hire great people, give them parameters, and turn them loose." And where equipment is concerned, whether it be new Allier oak barrels or a new red-wine fermentation facility, the sky's the limit.

Gore grew up in California and earned a degree in food science from California Polytechnic State University. He used school vacations and also took time off from school to work in Napa and Sonoma County wineries. He graduated in 1976, then went to work as a lab technician and later enologist for Myron Nightingale at Beringer Winery.

"It was like going back to college," he says of his days with Nightingale. In 1982 he moved to Washington to work for Chateau Ste. Michelle and became head red winemaker. When the Columbia Crest facility opened, he took the helm there.

Gore's "winery within a winery" concept is responsible for Columbia Crest's reserve and vineyard-designated wines. A special area of the winery is devoted to these wines, with Gore and only a few associates working on them.

"Even though we're big, we found a way to make small-lot wines," he says. "Winemakers always want options, and we've got them."

floor nearly twenty miles wide. The valley, drained by the Walla Walla River and its tributaries, is also the beneficiary of soils left by ancient volcanoes, windstorms, and floods, and is one of the basins formed by prehistoric Lake Lewis.

Like the Yakima Valley, the Walla Walla Valley is climatically more temperate than the greater Columbia Valley, more protected from fierce winter winds by the hills that surround it. Vineyard sites with gravel deposits left by ancient floods heat up quickly, hold the heat, and mimic the microclimates of the Chateauneuf du Pape region of southern France. These sites are particularly sought by growers wishing to plant Syrah.

The valley's modern-day vineyards and wineries were developed almost concurrently with those of the Yakima Valley to the west. In the Yakima Valley, Mike Wallace and his father, Jerry, founded Hinzerling Winery in 1976 and tended grapevines that were planted on their vineyard land in 1973. In the Walla Walla Valley, Rick Small planted his first six acres of winegrapes north of Lowden in 1977. In nearby Walla Walla that same year, his friend and golf partner Gary Figgins made the first wines at Leonetti Cellars.

While white wines from the valley are excellent, the emphasis has moved to reds: Cabernet Sauvignon, Merlot, Cabernet Franc, and most recently Syrah. The number of wineries has increased from a handful to more than twenty, ranging in size from small, boutique producers to large, well-financed operations. The city of Walla Walla is once again a center for grape growing and winemaking.

Puget Sound

The Puget Sound wine region of Western Washington stretches north to south from the Canadian border to just beyond Olympia. The Puget Sound area, shaped by the swelling and retreating of glaciers, has a cool and temperate climate. Some places in the region record only about thirty inches of rainfall yearly, though other parts receive considerably more.

Hybrids such as Campbell Early do well under such cool and damp conditions. They are early to ripen, and they resist mildew. The region successfully grows such cool-climate European varietals as Madeleine Angevine, Madeleine Sylvaner, Müller-Thurgau, Sylvaner, and Riesling, and American/European hybrids such as Siegerebbe.

Some fruit wines also are produced, as well as a bit of Pinot Noir and Pinot Gris. While these can be delicious, refreshing wines, their appeal primarily is local.

Right: Quaint and inviting Bainbridge Island Winery, just half an hour's ferry ride from downtown Seattle, depicts a different style and scale of grape growing than Eastern Washington. Puget Sound is home to cool-climate-loving grape varieties such as the Madeleine Angevine, Muller Thurgau, Pinot Noir, and several others that are grown on the island. Bainbridge Island Winery's owners Gerard and JoAnn Bentryn were instrumental in getting the Puget Sound recognized as Washington's fourth federally designated viticultural region.

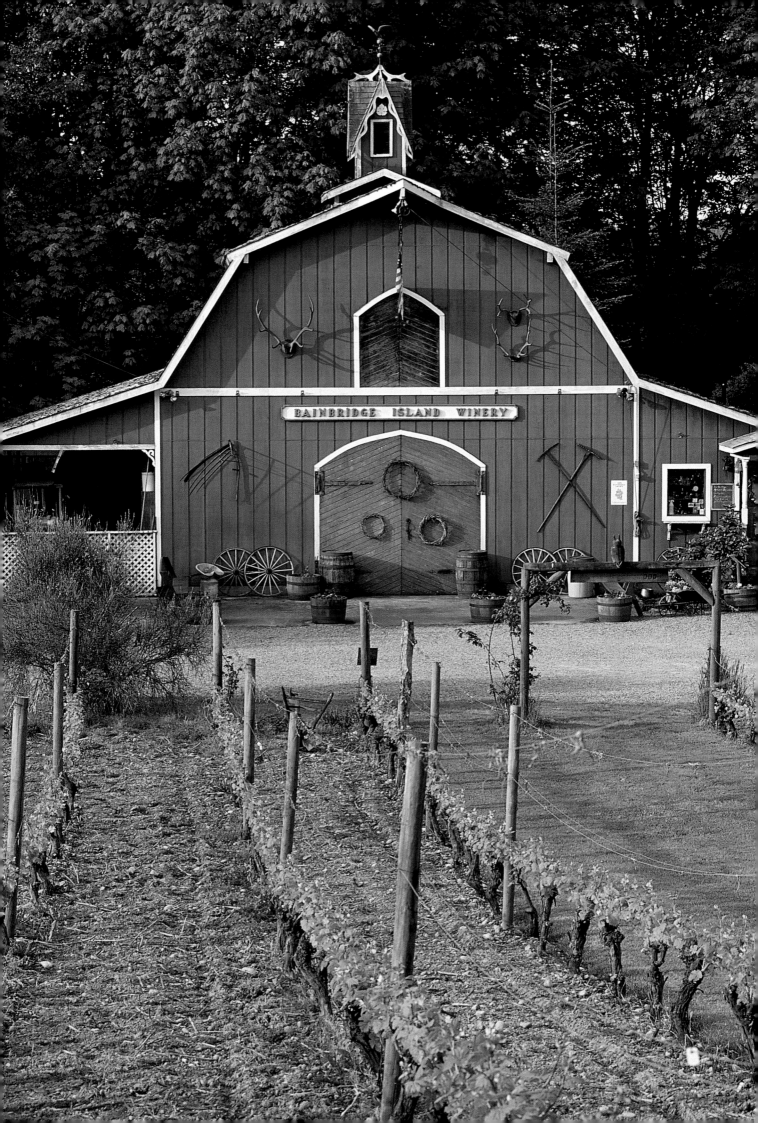

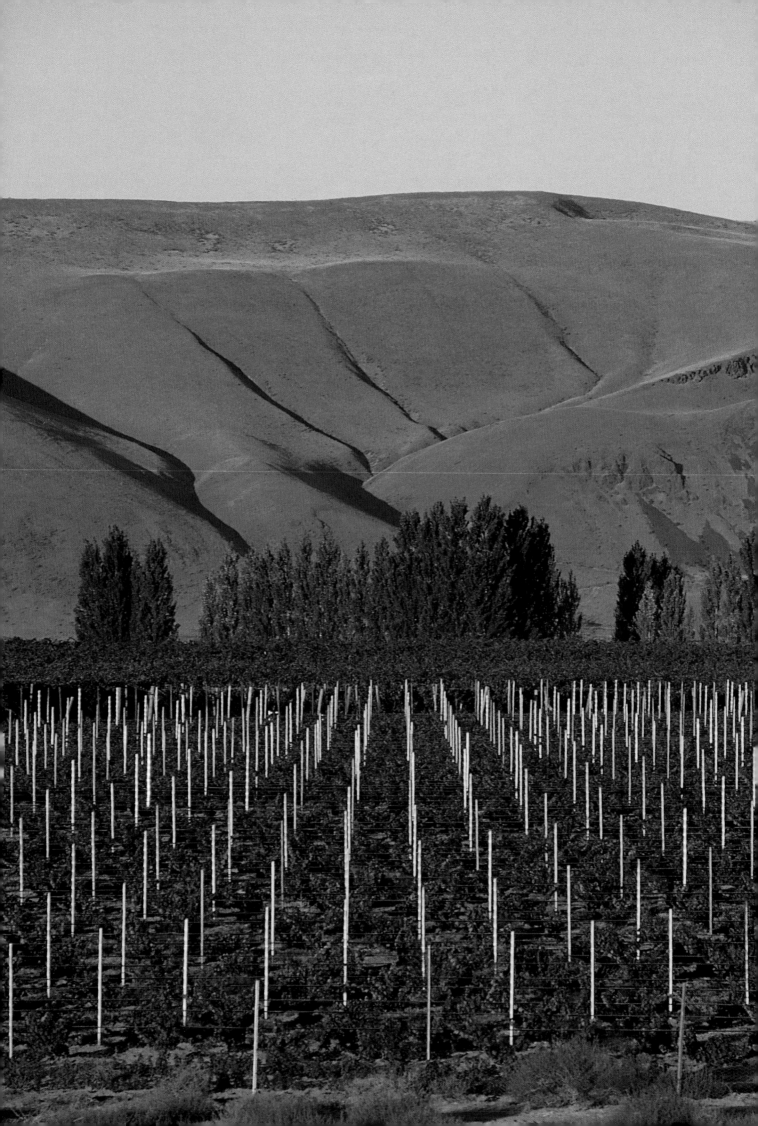

Bainbridge Island Vineyards & Winery, for example, uses only fruit grown at its seven-acre vineyard on the island and sells wines only out of its winery.

In contrast to the smattering of Puget Sound wineries that make distinctive wines from their own grapes are the wineries of Woodinville and the Seattle area that rely on grapes grown east of the mountains. Among these wineries are giants like Chateau Ste. Michelle and Columbia Winery along with small producers such as Andrew Will Cellars and DeLille Cellars.

While Puget Sound was the state's center for grape growing in the years following Prohibition, it accounts for less than 1 percent of Washington viticulture today.

Subregions

Washington's wine subregions are all on the eastern side of the state. The **Red Mountain** subregion is the warmest area of the Yakima Valley. Beginning with Kiona Vineyards in the 1970s, the vineyards of Red Mountain became renowned for their Cabernets and

Merlots. More than 800 acres of grapes now grow at Red Mountain, producing fruit used by wineries throughout the state in making distinctive red wines.

Major vineyard development at the **Canoe Ridge** subregion got underway in the late 1980s when California's Chalone Wine Group bought land on this desolate ridge overlooking the Columbia River, planted grapes, and christened the property Canoe Ridge Vineyard. This is not to be confused with neighboring Canoe Ridge Estate, more than 700 acres owned by Stimson Lane Vineyards and Estates, owners of Chateau Ste. Michelle, Columbia Crest, and other wineries. Canoe Ridge has proven itself an excellent site for Chardonnay, Cabernet Sauvignon, and Merlot. Airflow created by the sloping land helps protect winter-sensitive

Left: Kiona Vineyards and adjoining Klipsun Vineyards were among the first planted in the Red Mountain subregion of eastern Yakima Valley. Grapes from this warmest part of Yakima Valley produce strong, ageworthy red wines. Pioneered by Kiona, Red Mountain now boasts 800 acres of vineyard and six wineries. In the background are the Horse Heaven Hills, which form the Yakima Valley's southern border. *Above:* Puffy cumulus clouds, hiding behind tanks at Hedges Cellars, are common in the Red Mountain area on summer afternoons.

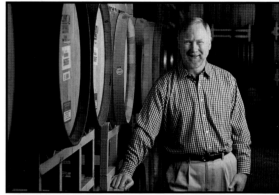

David Lake, M.W.
Columbia Winery, Woodinville

For more than twenty years, David Lake has been a principal player in the development of the Washington wine industry. Raised on both sides of the Atlantic, Lake always held a special place in his heart for the Northwest.

Lake worked in the British wine trade for ten years, earning its coveted Master of Wine title in 1975. He studied winemaking at the University of California at Davis and apprenticed at several Oregon wineries before accepting a position in 1979 at Columbia Winery (then Associated Vintners). The illness of the winemaker, Lloyd Woodburne, catapulted Lake into the leading role. With no introduction to Washington winemaking, he made decisions that resulted in excellent wines from an excellent vintage.

Lake visits Eastern Washington vineyards regularly throughout the year, working with growers, selecting blocks within each vineyard, and overseeing the vines as if they were his children. When Columbia had no vineyards of its own, Lake was able to control fruit quality by working with established vineyards. Corus Brands, Columbia's parent company, has now established more than 800 acres of vineyards at Alder Ridge overlooking the Columbia River.

"Winemaking is a work in progress," Lake says. "Nothing is ever static." His specialty always has been reds from the Bordeaux varieties, and he is one of the world's great producers of these complex and long-lived reds. He is excited by Syrah, and he was the first winemaker in Washington to make a commercial release of Syrah (in 1988).

Lake is experimenting with new Chardonnay clones, is expanding his work with Malbec as a blending variety, and is among those who believe the Tuscan variety Sangiovese has great promise in Washington.

Kerry Norton
Covey Run Vintners, Zillah

*Before becoming winemaker at Covey Run
Vintners, Kerry Norton spent most of his career
in Oregon's Willamette Valley. He was working
on his master's degree in food science at Oregon
State University when Barney Watson of the
school's enology program chose him to help
in the cellar at the research winery there.*

*Norton worked for five years at Alpine
Vineyards and then for eight years at Eola
Hills Winery, where he built a reputation as
a winemaker who could not only coax fabulous
flavors from a number of grape varieties but
also keep those wines in the moderate price
range. He became Covey Run winemaker in
September 1999.*

*Covey Run was founded in 1982 by a partner-
ship of Yakima Valley apple growers and quickly
became one of the valley's leading producers
of fine wines. It was purchased by Corus Brands
and now is the biggest producer in the Corus
winery portfolio and is known especially for
its Chardonnay and other white wines.*

*Covey Run plans to double production to just
over 300,000 cases yearly over the next several
years as the company's 800-acre vineyard at
Alder Ridge matures. The property is prime for
Cabernet Sauvignon, Merlot, Cabernet Franc,
and Chardonnay.*

*"With new grape sources, we will expand
primarily in reds," Norton says. "We are
pursuing a richer, softer style than in the past
and will be selling primarily in the medium
price range." He also looks forward to making
some single-vineyard and reserve wines in
higher price categories.*

grapevines from the worst of the cold. The slope faces
south and derives additional protection from the warmer
air mass that moves along the river. During a horrible
freeze in 1996, Canoe Ridge got its first real test. The
vineyards were virtually unscathed.

Immediately to the west of Canoe Ridge is the **Alder
Ridge** subregion. In terms of soils, site orientations,
and the protective influence of the Columbia River,
Alder Ridge has much in common with Canoe Ridge.
The more than 800 acres of vineyards planted at Alder
Ridge are owned by Corus Brands, owner of Columbia,
Covey Run, and Paul Thomas wineries. At approxi-
mately 1,000 feet altitude, it is one of Washington's
higher viticultural areas as well as one of its warmest.
It's an excellent site for Bordeaux reds and Syrah.

Immediately to the east of Canoe Ridge is the
Zephyr Ridge subregion. The moderately warm Zephyr
Ridge successfully produces a variety of red and white
grapes. The Hogue Cellars uses most of the grapes from
Zephyr Ridge.

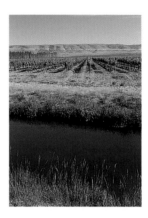

The Columbia River is a tricky devil. About twenty-
five miles south of Vantage, the south-running river
takes an abrupt 90-degree turn and flows east for about
twenty miles before turning south again. On the north
bank of the river's eastern foray is the **Wahluke Slope**
subregion, an expanse of southeasterly facing hillsides
that descend to the river. Several growers planted there
in the 1970s, including George Stewart of Stewart
Vineyards. It is a location favored particularly for its
Cabernet Sauvignon and Merlot. Stimson Lane's 660-
acre Cold Creek Vineyard, with its relatively steep, wide
slope, is home to some of the state's best Chardonnay.

The **Lower Snake River** subregion is located east of
Pasco where the Snake joins the Columbia. Several
large vineyards planted to Semillon, Sauvignon Blanc,
and Merlot flourish on the Snake's north bank.

Above: Rosebud Ranches' owners Don and Norma Toci moved
from Arizona to plant one of the early vineyards on Wahluke
Slope. They planted forty acres in 1979; their vineyard has since
grown to 253 acres of winegrapes. *Right:* Chris Figgins tends
barrels at the beautiful and efficient Leonetti Cellars in Walla
Walla. The winery was established by Chris's parents, Gary and
Nancy Figgins, in 1977 and continues to be recognized world-
wide for its excellent Cabernet Sauvignon and Merlot wines.

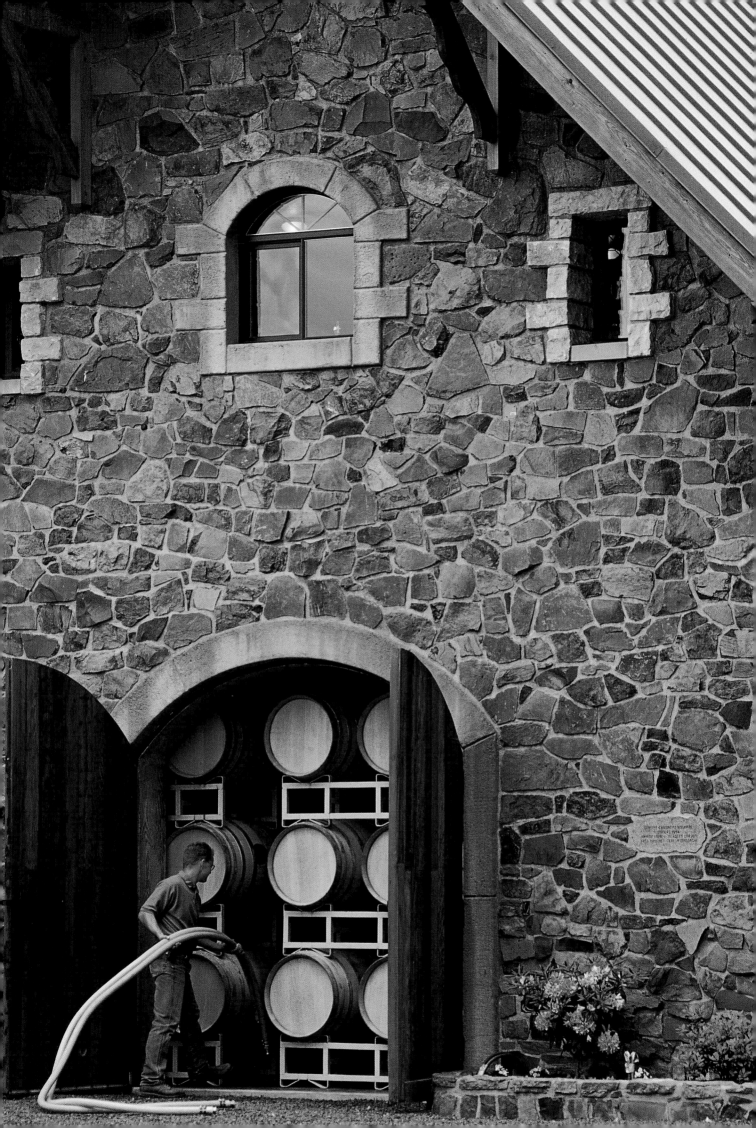

The Wines of Washington

Chris Upchurch
DeLille Cellars, Woodinville

The day in 1937 that Dr. Walter Clore went to work at the state experiment station near Prosser is a milestone in the history of contemporary Washington grape growing and winemaking. Massive irrigation projects plus plans for huge dams meant that a million acres of the Columbia River Valley would soon have water as needed. Clore's job as a horticulturist at the Irrigation Branch Experiment Station was to identify crops best suited for the region's overall climate and for its many microclimates. His work pointed the way toward the many varieties of grapes and wines that are produced in Washington today.

Clore originally came to the Northwest from Oklahoma on a horticultural fellowship to Washington State College (now Washington State University) in Pullman. When he took up his work at the experiment station, his focus was on tree fruits, berries, and grapes. Over the next four decades, Clore tested grapes and identified the best growing sites in the Columbia River Valley. He understood the problem of cold winters, but he found sites that could suit even traditional European winegrapes by taking advantage of the generous days of summer heat, dependable supply of irrigation water, and soils of silt, sand, and volcanic basalt that serve vineyards well.

The Washington Wine Project headed by Charles Nagel got under way in 1964 to make wines from the grapes Clore grew. By the time Clore retired in 1976, more than three hundred grape varieties were growing at the experiment station. For good reason Clore is known as the father of Washington's premium winegrape industry. He studied the grapes, discovered where to plant them, and brought together people of differing perspectives to rally behind the notion of Washington as a major producer of grapes born to become fine wine.

Today, from its position as the state second only to California in the production of premium *Vitis vinifera* winegrapes, Washington can only wonder what comes next. Steve Burns, executive director of both the Washington Wine Commission and the Washington Wine Institute, said in 1999 that, "When we did our 2020 plan we estimated Washington would have 60,000 acres of premium winegrapes by that year. But we didn't foresee the heavy planting of the last two years. . . . There

DeLille Cellars—formed by partners Charles Lill, his son Greg Lill, Jay Soloff, and Chris Upchurch —celebrated its first vintage in 1992. Grapes for the winery in Woodinville come from select blocks in Eastern Washington vineyards.

The winery focuses on a single premium red wine made from Bordeaux grape varieties. The wine, called Chaleur Estate Red, was an immediate success both with consumers and critics. Its maker is winery co-owner Upchurch, a man with a background in the Seattle restaurant business and a passion for fine wines.

Upchurch was born in Washington, D.C., and grew up in Princeton, New Jersey. He attended the University of Colorado, then moved to Seattle and earned a psychology degree from the University of Washington in 1976. He promptly went to work in the restaurant industry and also began making wine on his own in that same year.

"In the restaurant business, I gravitated toward wine," he says. "I took up amateur winemaking because I thought I'd be a better wine buyer if I understood it all from vineyard to bottle." To Upchurch, as to many Northwest winemakers, wine has artistic merit. He embraces the French ideal of wine as a complete unit— the sum of its parts—rather than viewing its components separately. He finds himself spending more and more time in Eastern Washington vineyards to increase his understanding of the wines he makes so well.

DeLille Cellars wines include its flagship Chaleur Estate Red, a tasty, ageable, primarily Cabernet Sauvignon Bordeaux blend; D2, a softer more approachable Merlot blend; Chaleur Blanc, a blend of Sauvignon Blanc and Semillon; and Doyenne, a Syrah. A small amount of Harrison Hill—a single-vineyard blend of Cabernet, Merlot, and Cabernet Franc—is made as well.

Left: A world of exciting Washington wines await adventuresome tasters, thanks in part to the work of Dr. Walter Clore and the Prosser Research Station. In 1964, the Washington Wine Project, headed by Charles Nagel, began making experimental wines from the grapes grown by Clore.

Eric Dunham
Dunham Cellars, Walla Walla

When Eric Dunham returned to his hometown of Walla Walla after a stint in the Navy, he wasn't certain what he wanted to do. He began to study irrigation technology and quickly became interested in wine, first making his own in small amounts in 1994.

Following a seven-month internship at The Hogue Cellars, in Prosser, Dunham was offered a job as assistant winemaker at L'Ecole No. 41, in Lowden. He learned on the job, took extension courses through the University of California at Davis, and began making his own wine in earnest during his four and a half years at L'Ecole.

Dunham's production grew to 1,100 cases in 1998, and he decided it was time to find a separate facility. He intends to develop the winery to produce 5,000 cases yearly.

Dunham Cellars' only commercial wine to date is an ultra-premium, 100 percent Cabernet Sauvignon. He makes a small amount of white wine for the winery itself, and he plans to make a bit of Syrah in the Australian Shiraz style. He purchases grapes from local growers, and he and his parents are planting their own vineyard near Lowden.

is no shortage of land. Depending on water availability, there is potential for 100,000 acres of winegrapes here by 2020."

Starting with the reds, following is a look at the grapes and the wines of Washington that are winning the attention of the wine world.

Merlot

Merlot wine began hitting its stride in the United States in the late 1980s, and by the early 1990s it had become wildly popular. The grape was planted throughout Washington in the mid-1970s, at a time when California Merlot had become *the* trendy red wine. By the late 1970s, virtually every winery in Oregon, Idaho, and Washington was making Merlot from grapes grown in Eastern Washington. It is now Washington's most-planted red variety.

This grape is one of the mainstays of the French region of Bordeaux, brought there presumably by the Romans on their treks through the conquered lands of

Europe. French Merlot traditionally was blended with Cabernet Sauvignon and lesser amounts of Cabernet Franc, Verdot, and Malbec in order to make a better wine. The addition of Cabernet adds backbone to the softer Merlot. Judicious blending of other varieties adds flavor complexity.

Cabernet Sauvignon is considered to be one of the "noble" European grape varieties that make the world's finest wines, while Merlot, for no especially good reason, is not. Cabernet tends to be more astringent in its youth, tougher to tame and therefore longer-lived. Merlot, on the other hand, is juicier and more forward, fruity in its youth, a bit rounder, softer, more approachable. It is higher in sugars and lower in tannins and acid than Cabernet. It offers what British wine writer Jancis Robinson calls a "brazen lusciousness."

Above: Wooden fermentation tanks at Staton Hills Winery. *Right:* Unique experimental trellising at Staton Hills Winery is unlike any other in the Columbia Valley. The winery is located a few miles east of Yakima, and was started by Yakima attorney Dave Staton and other investors in 1984. It was purchased by the Chalone Wine Group in 1999.

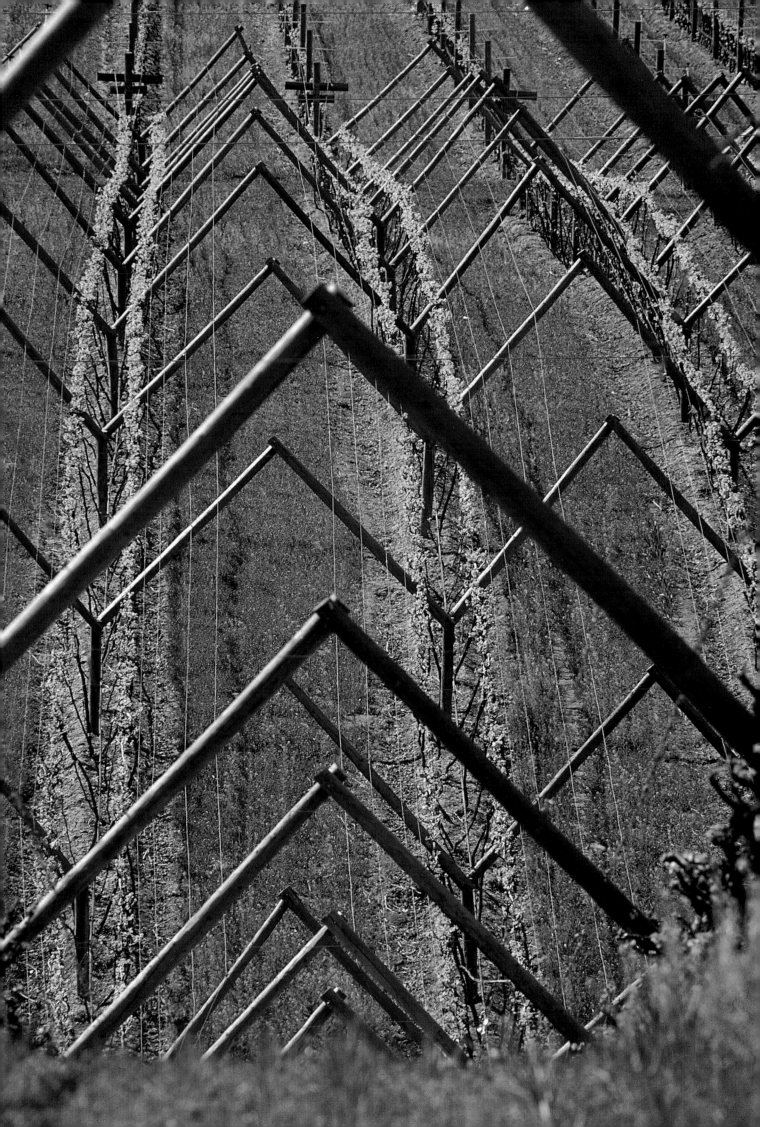

"It is said that the Merlot is the grape that the blackbird guzzles first," Robinson writes. Yet the wine is capable of cellaring very well. However, most Americans do not cellar wines and most Washington Merlot drinks well in its youth—facts that at least partially explain Merlot's resounding popularity.

Early on, Washington Merlot was plagued with an excessive vegetative quality—with flavors and aromas of such things as boiled beans, asparagus, even composting lawn trimmings. Although this taste could be subdued with aging, it took years, and most of us weren't willing to wait that long. But experimentation and hard work by the growers have paid off. Growers learned canopy management practices—controlling aggressive vine vigor with summer hedging and pruning—as well as when to withhold irrigation late in the season. As more and more Merlot vineyards reached maturity after ten years of cultivation, winemakers learned a great deal about working with the fruit. The problem of vegetative taste has been all but eliminated.

Merlot is more sensitive to Washington's cold winters than hardier varieties such as Chardonnay, Riesling, Syrah, and Cabernet Sauvignon. After many hard lessons, the successful growers are those that choose sites specifically agreeable to Merlot. This grape thrives particularly well on south-facing slopes, especially those close to water. This combination helps the vines avoid the worst of the Columbia Basin's chilling northerly winds while benefiting from the region's usually sunny days, even in winter. Canoe Ridge, on the Columbia River at Walla Walla, and similar sites are particularly favorable to Merlot.

Many Washington wineries make 100 percent Merlot wines. But it is widely accepted that Merlot benefits from blending with Cabernet Sauvignon. (And vice versa: Merlot is often invited to share space in the Cabernet bottle.) A bit of Cabernet Franc is sometimes introduced into the blend. Since federal law allows a blending of up to 25 percent of varieties other than that stated on the label, Merlot may contain some Cabernet Sauvignon and/or Cabernet Franc or Malbec without that fact being mentioned.

A food-friendly wine, Washington Merlot with its juicy fruit and bright acidity has been paired successfully with everything from grilled salmon to chocolate. A fruity young Merlot is a delicious sipper indeed. Enjoy it with grilled steak or standing rib roast, pork tenderloin with cranberry chutney, roast turkey, robust cheeses, duck, mushroom dishes, or a good hamburger grilled medium-rare.

In young Merlots, look for cherry, berry, and ripe plum flavors often tempered with vanillin and smoke character. In older wines, the aromas and flavors mellow

Lou Facelli
Facelli Winery, Woodinville

Someone once said all you need to make wine are grapes, a bucket, and two hoses. That's about what Lou Facelli had when he began making commercial wines in a shed in a field on the outskirts of Caldwell, Idaho. Facelli, of sturdy Italian stock, cared little for the glitterati of the winemaking world. In 1981 all he wanted to do was make good wine. And he did: Riesling, Chardonnay, apricot, and cherry.

When time came to expand, he chose as his partners the neighboring farmers who grew his winegrapes. A new facility was built, but within a short time the partnership fell apart and the Facelli winery was sold from under him.

Facelli took a whipping, but he still knew how to make good wine. He moved his family to the Seattle area and worked for the now-defunct Salmon Bay Winery. Another small winery, Haviland Vintners, underwent an expansion and hired him as winemaker, then promptly went out of business.

Facelli once again dusted himself off and rented a small space in Woodinville, determined to make his own wines with no help from investors/partners/employers, thank you very much. The first few years were tough, but the rebirth of his own winery is a Cinderella story.

Today, Facelli is one of Washington's best-loved winemakers. He his wife, Sandy, and two of their three daughters run the 4,000-case winery. Facelli's focus is primarily reds—Cabernet Sauvignon, Merlot, and Lemberger. He makes a bit of Pinot Noir with grapes from southwestern Washington and is working with Syrah, Cabernet Franc, and Sangiovese grapes purchased from growers in the Columbia Valley. Whites are Chardonnay and Fumé Blanc.

"In the last two years, it feels brand new," he says of his life today.

Left: Visitors line up to taste the delicious wines at Waterbrook Winery's hospitality room in downtown Walla Walla. The winery is located in Lowden and was started in 1984 by Eric and Janet Rindal in an old asparagus shed.

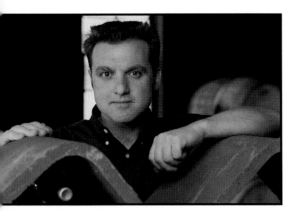

Rusty Figgins
Glen Fiona, Walla Walla

Berle "Rusty" Figgins Jr. never intended to start his own winery. In fact, he was a long-time admirer of older brother Gary Figgins and always planned to work for his brother at Leonetti Cellars.

Then in 1989, Rusty went to Australia and everything changed. He studied winemaking and worked with Syrah wines. Back in Washington he became vineyard manager at Pepper Bridge Vineyards, an ambitious new venture near Walla Walla.

He made his first Syrah in 1995 at the Waterbrook Winery facility, using grapes grown at Pepper Bridge. Today his Glen Fiona Winery is the only winery committed solely to red Syrah wines. He makes four of them. Included in the blends are other Rhone grape varieties including Grenache, Cinsault, and Viognier.

Where Gary Figgins drew upon his mother's Italian side for his winery's name, Rusty went with his father's Celtic heritage. Glen Fiona is Gaelic for "Valley of the Vine." The winery is housed in the former carriage house at the historic Kibler-Finch Homestead east of Walla Walla. Also on the property is the lovely Mill Creek Inn bed and breakfast.

into supple, subdued fruit with nuances of chocolate, mint, dried tobacco leaf, and smoke.

Cabernet Sauvignon

In Washington as in Bordeaux, Cabernet Sauvignon is *the* noble red grape, known for its depth, strength, and longevity. It is the state's second most-planted red, after Merlot. Particularly important for Washington, the Cabernet vine boasts particularly hard wood, making it more winter-hardy than Merlot. The grape is a late bloomer, which usually exempts it from spring frosts, and it has a relatively gradual and noncritical ripening cycle.

With naturally small, thick-skinned berries, Cabernet Sauvignon yields an intensely flavored and tannic wine. Compared with Merlot, the plant bears stingily. And many Cabernets are tannic, astringent, and unapproachable in their youth.

Washington Cabernet once had the same problems with vegetative character that had to be overcome in

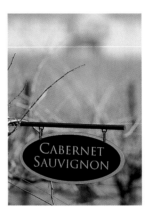

Washington Merlot. But with improvements in growing practices and winemaking as the industry matured, Cabernet aromas and flavors have evolved from predominantly bell pepper and mint to the more correct and desirable black currant, cherry, and berry fruit with cedar and herbal nuances and toasty oak taking supporting rather than leading roles.

Washington's truly great Cabernets now hold their own with the best from Bordeaux or California or anywhere else this great grape is grown. Wine judgings throughout the world attest to this. Rick Small at Woodward Canyon Winery and Gary Figgins at Leonetti Cellars are among the stars in making Washington Cabernets. The variety's great success in Washington is also due to the work of David Lake at Columbia Winery and the folks at Stimson Lane Vineyards and Estates.

Above: The sign says it all: Eastern Washington is Cabernet Sauvignon country! *Right:* Hedges Cellars' huge chateau-style winery was built at its Red Mountain vineyards site in 1995. The winery actually began in Issaquah in 1989, several years after founder Tom Hedges began blending Washington wines and selling them to Sweden.

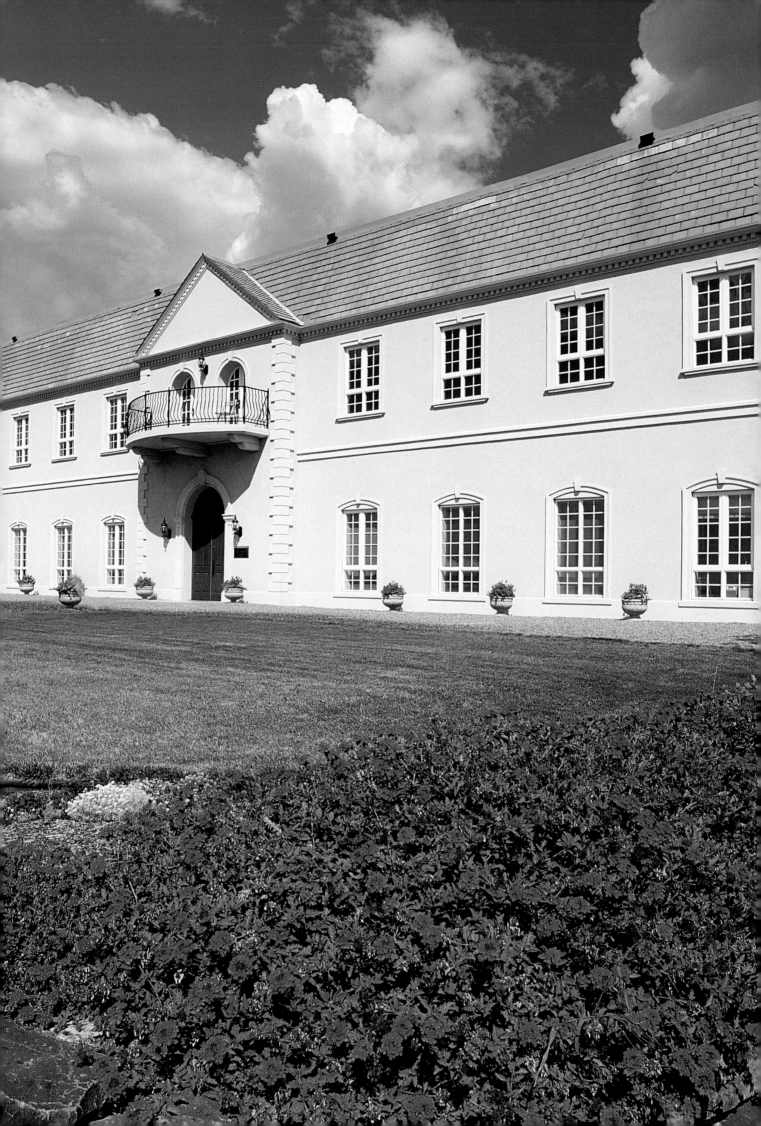

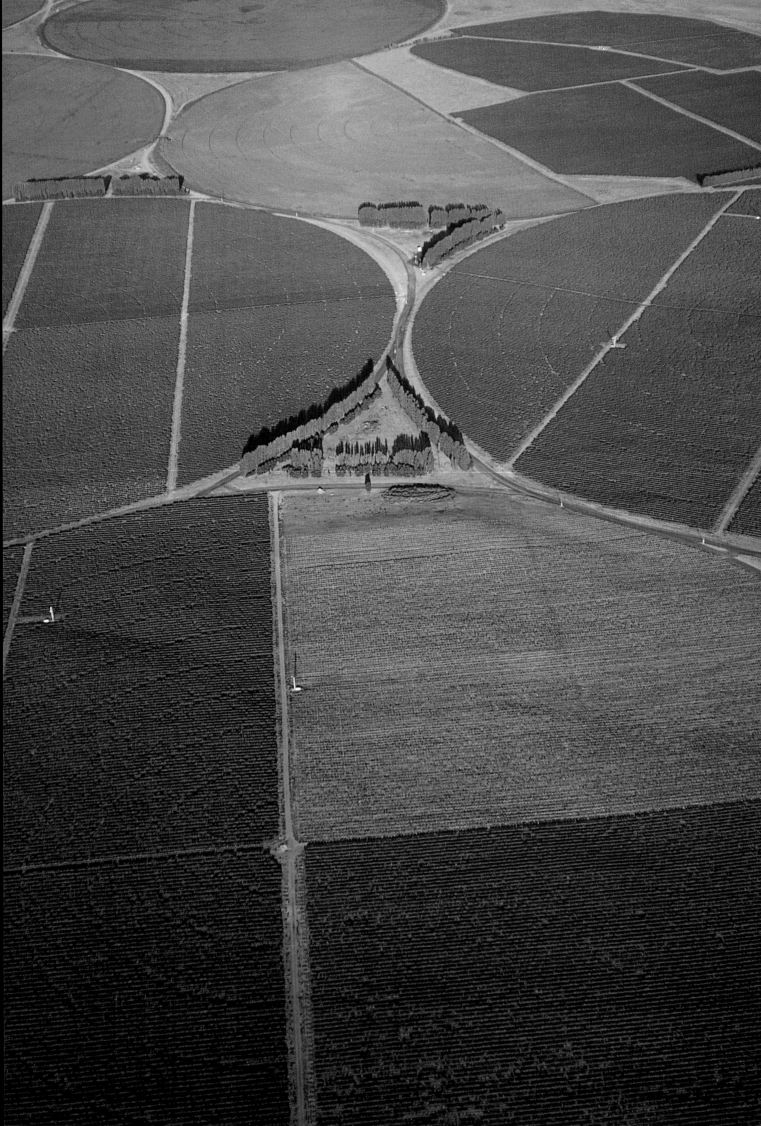

Marie-Eve Gilla
Gordon Brothers Cellars, Pasco

Marie-Eve Gilla is a native of Paris—but with family in the Jura region between Burgundy and Switzerland, she is a country girl at heart. "I liked farming," she confesses. She moved to Dijon to study viticulture. While there she began enjoying wine in earnest and decided to study enology.

After graduating from the University of Dijon's enology program she came to the Northwest, where she worked for several wineries in Oregon, including a ten-month stint at Argyle Winery in Dundee. Moving to Washington, she was at Covey Run for four years, worked the 1996 harvest at The Hogue Cellars, and then was hired as winemaker for Gordon Brothers Cellars, which had just completed a new facility in Pasco.

Gilla has increased annual production at Gordon Brothers from 3,500 cases to about 10,000 cases—a comfortable level that suits her hands-on style. Gordon Brothers is a diversified farming operation that for many years sold most of its grape crop to other wineries. Wines are made exclusively from estate grapes—a necessity, Gilla believes, for quality control.

The winery is known for its reds—Cabernet Sauvignon and Merlot—and recently planted 15 acres of Syrah. "It's so hot here, I think it is the perfect place to grow Syrah," she says.

Lake arrived in 1979 at Associated Vintners (which later became Columbia Winery), intent on making great red wines. Well-versed in the great red wines of Bordeaux, he knew what he was looking for—intense fruit, layers of complex aromas and flavors, and an ability to age well. The question was how to get to that goal.

Lake learned that young vines seemed more susceptible to the vegetative quality undesirable in Cabernet. Part of the problem was resolved as vineyards reached the ten-year mark. Too much water also seemed to be a factor, but that effect could be controlled in Eastern Washington by adjusting the amount of irrigation. Pruning back the leaf canopy in summer also helped. Working with established Washington grape growers and learning from growers in other parts of the world, Lake established what is now known as Columbia's David Lake Signature Series—Cabernets from select sites in Eastern Washington.

At Chateau Ste. Michelle (which later came under the Stimson Lane umbrella), Allen Shoup became vice president for marketing in 1980, ready to do whatever it would take to create some of Washington's best Cabernet and Merlot. Shoup persuaded parent company U.S. Tobacco to make a long-term commitment to producing top-quality Washington wines. Talented winemakers such as Joel Klein, Cheryl Jones (nee Barber), and Kay Simon, and more recently Doug Gore, Mike Januik, and Charlie Hoppes, plus visionaries like Bob Betz, got the job done.

Washington is now a leader in quality Cabernet Sauvignon production. A flurry of vineyard developments, new small wineries, and an influx of large, well-financed operations assure its future in the state.

With its unyielding aromas, dense fruit, and astringent tannins, young Cabernet Sauvignon is seldom inviting, although a good dose of Merlot blended in does help. Washington Cabs start to open at about five years after vintage and really start showing well at ten years. It is then that the tannins soften, the fruit opens and becomes voluptuous, and complex aromas and flavors start to emerge. Fruit flavors often are described as black currant, black cherry, ripe berry, and sometimes plum. These are complemented by hints of cedar, mint, coffee, chocolate, and herbs. Some find a suggestion of bell pepper and even a bit of leather.

A young and fruity Cabernet (if you can find such a specimen) is excellent with grilled steak, hearty pasta dishes, even grilled salmon. However, classic wines invite classic food matches. Serve mature Washington Cabernet with prime rib, filet mignon, venison, and aged cheeses.

Left: These circular vineyard plots were originally laid out to accommodate huge rotating sprinkler systems. As water availability has become a more pressing issue, these vineyards surrounding Columbia Crest Winery have been converted to drip irrigation, which better conserves this precious resource. *Overleaf:* Early morning sunshine at Red Willow Vineyard casts a rosy glow to snow-covered vineyards.

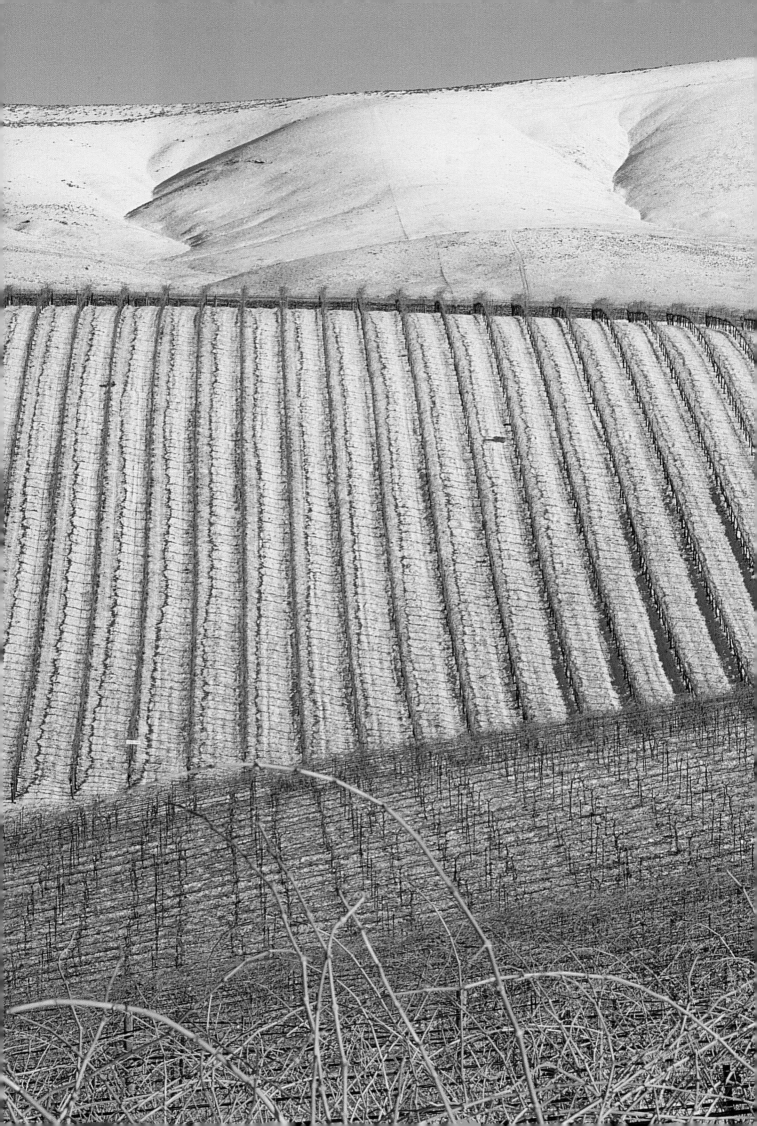

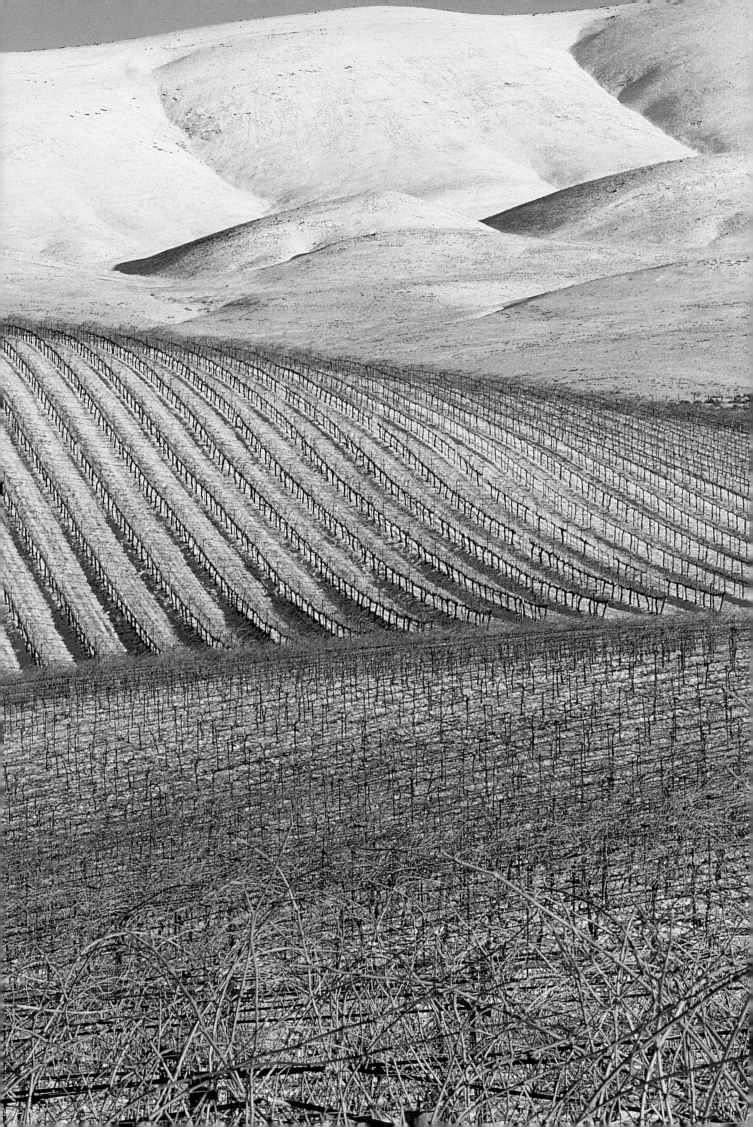

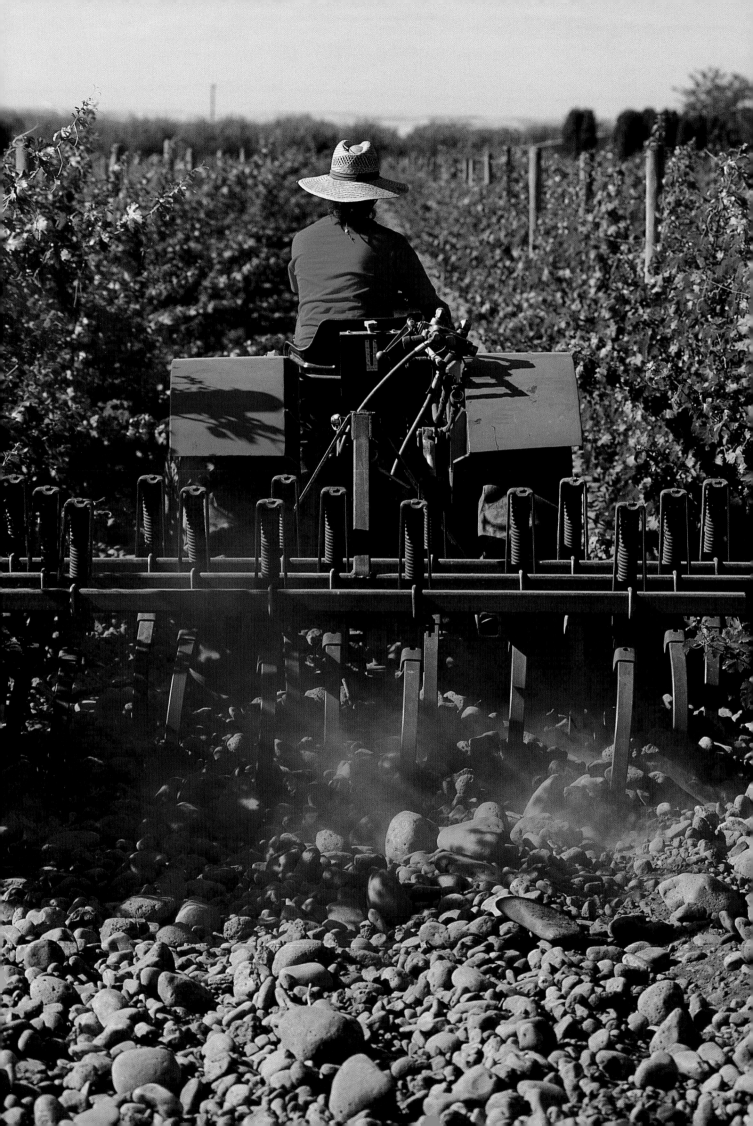

Syrah

One of the most interesting developments in today's Washington wine scene is the emergence of Syrah as a major red variety. While other varieties took a break, Syrah was being heavily planted during 1998, 1999, and 2000. During those years, Cabernet Sauvignon, Merlot, and particularly Syrah grapes were demanding the highest prices, as reds continued their march toward dominance in Washington. "Since I came to Washington," says Steve Burns of the Washington Wine Commission, "it has changed from a white-wine state to a red-wine state."

Of the classic grape varieties, Syrah is the oldest. It most likely originated in the Middle East, near Shiraz in southeastern Iran. It may have been brought across the Mediterranean and into southern France by the Phoenicians. The vine was well established in the Rhone Valley when the Romans arrived, and has grown happily in France for thousands of years.

Easy to grow, Syrah thrives in high temperatures

and rocky or gravelly soil that is low in nutrients. It is a much more generous bearer than Cabernet, and is not cold sensitive. All this makes Washington grape growers very happy. However, its sites must be carefully chosen, and growers are still seeking the best ones.

Though easier to grow than Cabernet Sauvignon, the Syrah grape is harder to turn into a truly great wine. Growers must attend closely to yield, not letting it get too high and thereby lessening the fruit's intensity. During winemaking, Syrah is prone to oxidation, or browning. At its best, Syrah makes a deep and concentrated wine that takes several years of bottle aging to show its best.

Left: Stony deposits like this one at Cayuse Vineyard in the Walla Walla Valley inspired French emigrant Christophe Baron and others to plant Syrah. The terroir—lay of the land and soil composition—reminded Baron of the Hermitage and Chateauneuf-du-Pape regions of France where that country's famous Syrahs are grown. *Above:* Glen Fiona and McCrea Cellars are two small Washington wineries specializing in Syrah production.

Tom Hedges
Hedges Cellars,
Issaquah and Benton City

Before Hedges Cellars existed, Tom Hedges was making a name for himself in the wine industry by brokering Washington wines to Europe.

As an international agricultural commodities broker, Hedges was asked in 1986 by the Swedish national alcohol monopoly to find Washington red wines available for bulk shipment to Sweden. Hedges sent samples in the price range requested. The tasters in Sweden chose a Cabernet Sauvignon and a Merlot; Hedges had the two blended and shipped to Sweden for bottling and distribution.

The wine was called Hedges because it needed a name and that's the first one that came out of Tom's mouth. It was an instant hit with Swedish wine critics, and Hedges was in the wine business big time. His method: Buy finished wines, blend them, and ship them.

The Hedges family then decided to plant a vineyard and begin making their own wines. Hedges consulted with several winemakers and decided on the Red Mountain subregion just outside Benton City and began planting the vineyard in 1991.

Hedges Cellars made its first wines in 1989 from purchased grapes. "We wanted a $15 red wine we could sell for $10," Hedges says. Brian Carter was in charge of winemaking, producing tasty Cabernet-Merlot blends at the desired price point.

By 1994, Hedges Cellars was producing wines from its own grapes grown at Red Mountain, as well as from other local growers. In 1995, the winery shipped more than 60,000 cases and built a chateau-style production facility at Red Mountain.

HOGUE

Co Dinn, David Forsyth, and Nicolas Quille
The Hogue Cellars, Prosser

Since its beginnings in 1982, The Hogue Cellars has evolved from a modest family winery into one of the Northwest's largest. As a result it now requires a winemaking team to get the job done.

Director of winemaking is David Forsyth, who holds a degree in zoology from Central Washington State University and a master of science degree from the University of California at Davis, where he became enamored of the wine industry. Forsyth worked in Napa Valley wineries and as a ski instructor before joining The Hogue Cellars in 1984.

Texas native Coman Dinn, white winemaker, worked in the Texas oil industry before turning his attention to winemaking. He earned a master's in enology at U.C. Davis and worked at Trefethen Vineyards in the Napa Valley before moving to The Hogue Cellars in 1996.

Nicolas Quille, red winemaker, was trained in his native France and worked in several of its wine regions. In the United States, he worked as assistant winemaker at California's J. Lohr Winery and joined The Hogue Cellars winemaking team in 1998.

The Hogue Cellars co-owner Mike Hogue became intrigued with winegrapes in the industry's early years in Washington. He grew Concord grapes on the family's large, diversified farming operation near Prosser and prospered growing hops during the 1970s and 1980s. Today he manages The Hogue Farms—1,600 acres of winegrapes, apples, asparagus, hops, and Concords. His brother, Gary, left his marketing job in Seattle to become president of the winery. The brothers' combined skills and their knack for hiring talented winemakers have made the winery a major Washington success.

Columbia Winery's David Lake made Washington's first Syrah, in 1988. Though he began making Syrah after Lake, Doug McCrea of McCrea Cellars made the earliest commitment to the Rhone varietals—Syrah, Viognier, and Grenache—and today devotes nearly half of his annual production to Syrah.

While many Washington Syrahs are spendy indeed, several wineries have released Syrahs that are less expensive and more forward—more drinkable in their youth. Says Brian Carter of Washington Hills Cellars: "I can't see why there aren't more twelve-dollar bottles of Syrah. There are more suitable sites than originally thought."

The more forward Washington Syrahs have a jam-like, spicy character. The Syrahs that are built to last have closed, tight fruit and roasted coffee fragrances that open with time to deep, complex aromas and flavors of blackberry, black currant, pepper, clove, plum, roasted coffee, and sometimes leather. The more fruity renditions are best with grilled meats and hearty pasta dishes, even cassoulet. The great aged Syrahs are recommended with simply prepared red meats and aged cheeses.

Chardonnay

Chardonnay is the most-planted premium wine-grape in Washington. Native to the Burgundy region of France, this white grape is thought of universally as a cool-climate variety. But Eastern Washington's daytime temperatures during growing season are anything but cool. The Chardonnay clones used in Washington were developed at the University of California at Davis to ripen later than their Burgundian counterparts. This allows the fruit to linger longer on the vines, developing complex and mature flavors.

A hardy, adaptable grape, Chardonnay is widely grown in many parts of the world. The plant produces vigorous and abundant foliage that often must be cut back. It buds early, and thus the biggest worry for Eastern Washington growers is heavy spring frost.

Chardonnay is a chameleon. Climate and soils certainly affect its flavors and acid levels, but it also is the grape most influenced by winemaking. Much of what consumers attribute to Chardonnay flavor has more to do with winemaking than with grape growing. Flavor is greatly influenced by the type of oak barrels used for wine storage, the length of time the wine is aged in oak, and the degree to which the oak is toasted (that is, purposely charred on the interior during assembly).

Also important is whether or not the wine goes through the secondary fermentation known as malolactic fermentation, and whether it ages on its lees (the

Right: Ripe Chardonnay clusters glow a beautiful, translucent yellow-green. Chardonnay, the most-planted white variety in Washington, is made into a number of wine styles, ranging from fruity to the massive, barrel-fermented wines that rival Burgundy's famed Montrachets.

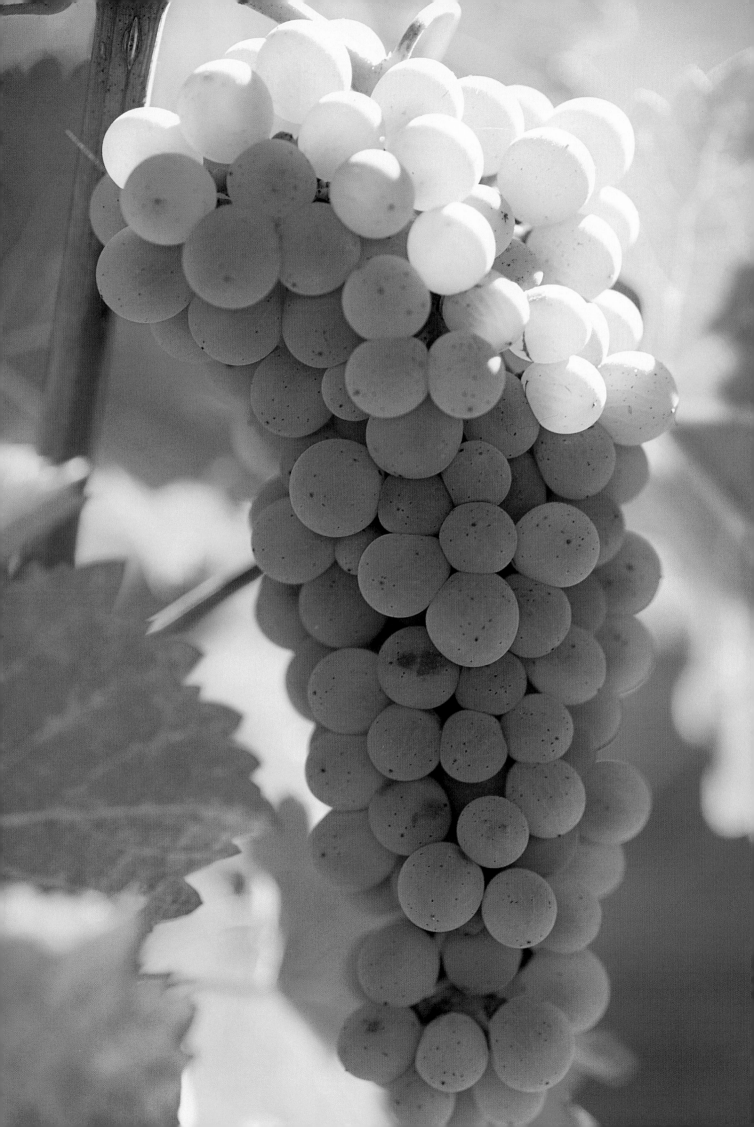

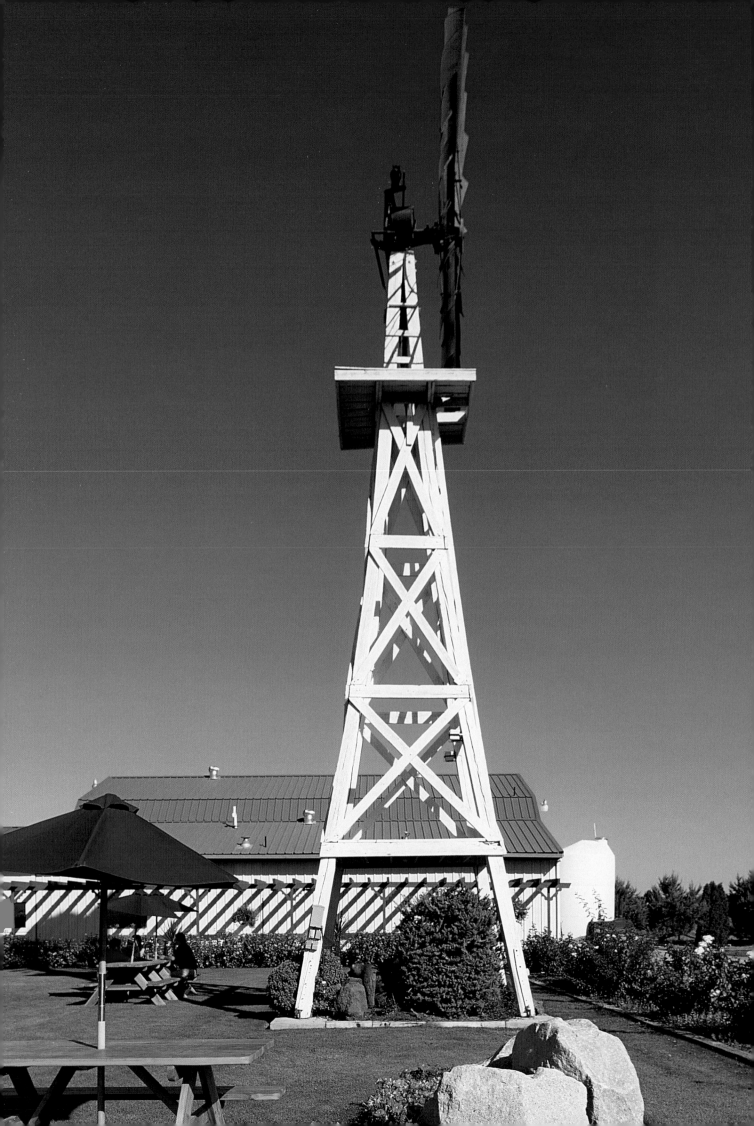

dead yeast cells that remain after fermentation is complete) or is left to age only after the yeast is filtered out.

Washington Chardonnay can have the mouthwatering aroma of a fresh, crisp apple with a subtle, flinty earthiness in the background. Depending upon where the grapes were grown and when they were picked, that apple taste could be Golden Delicious or Fuji or Royal Gala or Jonathon. The creaminess some associate with Washington Chardonnay may be the influence of malolactic fermentation and/or lees contact during aging. Toast and vanillin aromas and flavors show the winemaker's touch in the use of oak, amount of barrel toast, and the ratio of new oak to oak that previously has had wine aged in it. The use of more new oak yields more toast and vanillin character in the wine.

Certain about good Washington Chardonnay is that it will have enough rich, intense fruit flavor to stand up to the oak in which it is aged. Achieving ripe, delicious fruit has rarely been a problem in the Columbia River Valley, with its warm, dry growing season. Also certain is that the wine will have crispness, a firm backbone of acidity that makes many of these wines age well for a decade or more.

Its fresh acidity enhances the flavors of many foods, making Washington Chardonnay a marvelous match with roasted Walla Walla sweet onions, wild mushroom soups or tarts, roasted fowl, pork, and tomato-based dishes. Complex, mellow, older Chardonnays are particularly fine with wild mushroom dishes and a variety of ripe cheeses.

Riesling

Riesling was the first of the four noble European grape varieties to be planted in Washington, cultivated by the early 1970s by grape growers both east and west of the Cascades. The other noble varieties—Chardonnay, Cabernet Sauvignon, and Pinot Noir—followed. Riesling truly is a versatile white grape, growing happily in a wide range of climates.

The strong, dark wood of the Riesling vine makes it winter-hardy, a big plus in Eastern Washington. A late-ripening grape, it seems impervious to the autumn rains common in Western Washington. Riesling thrives on slate soils and sandy loams that are well-drained, found in both the eastern and western parts of the state. It prefers cool weather, showing less vine vigor in warm climates.

Early the darling of the Washington wine industry, Riesling is a grape whose plantings have stabilized in recent years. There is demand for light, refreshing, slightly sweet wines, and a sea of these have been made

Ray Sandidge
Kestrel Vintners, Prosser

Ray Sandidge was working with winegrapes as a researcher at the Prosser Research Station in Eastern Washington when he became interested in winemaking.

"I was no longer satisfied doing research papers," he remembers. "I became fascinated with the lore and romance of wine." The 1985 crush found him on Long Island working as assistant winemaker at Pindar Vineyards, mentored by Dmitri Tchelistcheff (the son of Napa's Andre Tchelistcheff) and Pindar winemaker Alan LeBlanc-Kinne. By what Sandidge describes as "a series of good fortunes," Pindar's 1986 Reserve Chardonnay and 1986 Reserve Cabernet Sauvignon were served at the inauguration of President George Bush.

Sandidge went on to work for three years as winemaker at a modest-size winery in Germany's Rheingau. He returned to Washington in 1991, where he worked at the now-defunct Cascade Estates Winery and then became winemaker at Hyatt Vineyards and finally at Kestrel.

Kestrel, owned by Florida businessman John Walker Sr. and his wife, Helen, produces 11,000 cases of wine yearly. Its focus is on reds. About 90 percent of production is Cabernet Sauvignon, Merlot, and Syrah. Sandidge also makes some Chardonnay. And he wants to make ice wines— in which the grapes actually freeze on the vine—from Pinot Gris and Viognier.

"I personally think Syrah will eventually surpass Merlot's popularity," he says of Washington's current darling. "It's darker, spicier, fruitier, and is a natural next step for Merlot drinkers."

Left: This windmill is the distinguishing landmark at Hyatt Vineyards, located north of Zillah in the central Yakima Valley. The winery was started in 1987, but owners Leland and Lynda Hyatt began growing grapes in the 1970s. The winery and 97-acre vineyard offer a spectacular view of the Yakima Valley and Mt. Adams. Hyatt is renowned for its Merlot and a variety of sweet, late-harvest wines.

Kiona
Vineyards and Winery

Scott Williams
Kiona Vineyards, Benton City

In the 1970s two Hanford engineers, Jim Holmes and John Williams, began making wine in the Holmes garage in Richland. Before long, Kiona Vineyards became a commercial entity in the Williams basement and both families were up to their eyeballs in grapes. Kiona is the Indian name for the foothills where the winery's home vineyard was planted.

Located just outside Benton City at the eastern end of the Yakima Valley, Kiona was the first winery to plant vineyards in the warm Red Mountain region. Kiona purchased the adjacent Ciel du Cheval vineyard in 1991. In 1994 the Holmes family retired from the winery business. They ended up with the Ciel du Cheval vineyard while the Williams family continued to own the winery.

Scott Williams, son of John and Ann Williams, grew up in the Washington wine industry. He is now general manager and winemaker at the 20,000-case Kiona winery.

"Before I got involved, Kiona was very small," he says. But the wines were good, and as the families learned about winemaking, the good got better. The winery's reputation is solidly established in big red wines, and the grapes from Red Mountain make some of Washington's best.

Kiona grows half of its own grapes and buys the remainder from diverse sources. "This spreads out the risk," says Scott Williams, who learned the hard way. Kiona's original vineyard is not the most winter hardy.

The Cabernet/Merlot blend is Kiona's high-volume red wine. The winery also is known for its deep, luscious Lemberger and produces about 4,000 cases a year. Other reds include Syrah, which was planted in 1994, a smattering of Zinfandel, and Kiona's estate-bottled reserve Cabernet.

from Riesling grapes the world over. But to make such wines from overly high-yielding vines, thereby diluting Riesling's fine flavors, is to do a great disservice to a lovely grape. Riesling is a thoroughbred and deserves to be treated as such.

The world's finest Rieslings come from Germany, where the grape is thought to have descended from a wild Rhineland vine, and from the Alsace region of France. German winemakers have mastered the art of making complex, fruity-flinty, low-alcohol wines that live forever. How do they do this? Centuries of practice. In Alsace, long, cool autumns are ideal for Riesling. The grape hangs on the vine late into the season, reaching higher sugar levels than in Germany, then is fermented into bone-dry wines of intense flavor, high alcohol levels, and remarkable ageability.

American winemakers still have a lot to learn about Riesling. Washington producers have put forth considerable effort, and as a result offer consumers fine Rieslings in a variety of styles. Only a few are made in

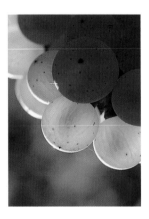

the dry Alsatian style. More common in Washington are wines that are moderately sweet, ranging from approximately 1 percent to 3 percent residual sugar. Unless one is careful about crop levels and painstaking in the winery, the result can be a soft, sweetish, watery—and boring—wine.

Some of the most intriguing Rieslings in Washington, and throughout the world, are made from very sweet, late-harvest grapes that have been infected late in the season by a mold, *Botrytis cinerea*. Brought on by moisture as nights become cooler and heavy dew appears, this "noble rot" grows on the grape skins, causing pinprick holes. The grapes shrivel as they lose moisture during the warm fall days—but the mold imparts elusive flavors of intense honey and burnt sugar, and an odd creaminess. The result is some of the world's most impressive dessert wines.

Above: Riesling grapes at harvest. *Right:* Ross Mickel, assistant winemaker at DeLille Cellars, revels in the spicy, juicy aromas of freshly crushed Cabernet Sauvignon grapes.

Over the years, delicious Rieslings in a full range of styles have come from many Washington wineries, including Chateau Ste. Michelle, Paul Thomas, and Washington Hills Cellars. You need to taste carefully to find the best, but they are out there.

The aromas and flavors of Washington Riesling can be most alluring. Peach, apricot, jasmine, and faint honey are among the most appealing. The wines can be tart when young, and often leave a fresh, green-apple aftertaste.

The slightly sweet Rieslings are delicious sippers and make good company for white fish, Asian and fusion dishes, ham, pork with fruit sauce or chutney, sweet shellfish such as Dungeness crab, and roast fowl. Those rare, sturdy, high-alcohol dry Rieslings demand substantial foods such as *choucroute garni*, roast pork, smoked trout, or a good Muenster cheese. Sip the dessert Rieslings as desserts in their own right, or serve them with a not-too-sweet fruit dessert.

Sauvignon Blanc

Sauvignon Blanc is from the French word *sauvage*, and in some incarnations it does have its wild, or savage, side. And when Robert Mondavi used the French word *fumé*, referring to smoke, to coin the name *Fumé Blanc*, he capitalized on one of Sauvignon Blanc's unique characteristics—its flinty, almost gunsmoke quality, which is enhanced by oak aging.

The wild and woolly, aggressively herbal Sauvignon Blancs of Washington's past are almost history. Canopy and water management in the vineyard and the fine-tuning of winemaking practices have tamed this grape into a respectable and important member of the Washington family of premium winegrapes.

In France, Sauvignon Blanc, along with Semillon, is the key ingredient in the great white wines of Bordeaux. Sauvignon Blanc is grown extensively in the chalky soils of the Upper Loire Valley. It is a weak sister in pedigree when compared with Semillon, but blended with Semillon, delicious things often happen. On its own, Sauvignon Blanc makes a perfect wine for the American market: forward, sassy, easily recognizable, and quite friendly with a great many foods.

Washington wineries produce excellent Sauvignon Blanc wines. Many wineries blend with Semillon to the degree that they must be called Sauvignon Blanc/Semillon or given proprietary names—that is, the Semillon constitutes more than 25 percent of the blend. In Washington Sauvignon Blancs, look for aromas and flavors ranging from citrus and pineapple to grass and herbs. A flinty, gunpowder aroma is almost always present in some degree, and when the wines are barrel-aged, they become smoky, oaky, and mouthfilling.

Left: Before harvest, small quantities of winegrapes are picked and squashed. Then the juice samples are analyzed to determine sugar levels and flavor maturity. In the frenzied days before picking, this process may be repeated several times.

Marty Clubb
L'Ecole No 41, Lowden

For Marty and Megan Clubb, the transition from the business world to the wine world was more about lifestyle and family than it was about an overriding passion for wine. "We love wine, but back then we also loved our jobs," says Marty.

In the 1980s, Marty and Megan lived in San Francisco and had high-level, corporate jobs that took them all over the country. "Basically we lived out of planes," Marty explains. After having two children—one in 1986, the other in 1988—the Clubbs decided to make some changes in their lives so that they could spend more time as a family. Megan's parents, Baker and Jean Ferguson, had opened L'Ecole No 41 in 1983, and by 1988 they were getting ready to retire. So the Clubbs researched the wine business, and Marty took winemaking courses as the University of California at Davis. "We came because of the opportunity," says Marty. The passion came later.

When the Clubbs took over L'Ecole in 1989, it was not a moneymaking operation. The first few years the Clubbs used their business expertise to get the winery running more efficiently. Marty improved the wines with the help from local winemakers, and L'Ecole wines gained recognition. Not incidentally, since then Marty has given a hand to other up-and-coming winemakers—payback for the help he received in the early days.

"Now it's really, really fun," he says. "And we do have a lot of family time." In addition to turning out lovely wines, the Clubbs have transformed the old Lowden schoolhouse into a center for food and wine events. At least twenty times a year, a chef drives across the mountains from Seattle to put on winemaker dinners and other events at the winery.

L'Ecole Nº 41

Leonetti Cellar

Gary Figgins
Leonetti Cellar, Walla Walla

Gary Figgins and his wife, Nancy, founded their small winery, Leonetti Cellar, in 1977. It was the first modern-day winery in the Walla Walla Valley and from the very beginning bespoke the quality for which the valley now is known.

Figgins first learned about wine from his grandfather, Frank Leonetti, who immigrated to the valley from Calabria, Italy. Figgins studied the winemaking techniques of France, Italy, and California, reading everything he could get his hands on. And he made experimental wine for eight years before going commercial.

The Leonetti wines—a sturdy Cabernet Sauvignon laced with Merlot, and a softer, more voluptuous Merlot with a touch of Cabernet for backbone—are made in modest quantity and sell out in a nanosecond. This has not moved Figgins to grow larger to meet demand. He is dedicated to making the very best handcrafted wines.

Grapes come from a handful of local growers plus the winery's own small vineyard. The wines are handled gently, aged in new French and American oak, and blended carefully. They are very expensive and worth every cent.

In 1989, Gary and Nancy Figgins built a compact stone mini-chateau behind their home in Walla Walla. The cellar, with its gentle light and rows of aromatic barrels, is a wine groupie's dream come true. But it is difficult to get an audience with Washington's elusive Emperor of Red Wine. He enjoys his family and friends, lives modestly but well, and passionately pursues the work he loves.

The only reliable way to purchase Leonetti wines is to get on the mailing list. Yet if you call the winery, you most likely will get a recording telling you the mailing list is full!

Sauvignon Blanc is good news for vegetarians because it partners well with steamed artichokes, grilled asparagus, lentil dishes, pastas, and cheeses. Blended with Semillon, it makes a fine complement to fish and shellfish. Like Riesling and Semillon, Sauvignon Blanc grapes may host the *Botrytis cinerea* mold, which imparts a honeyed creaminess, yielding some pleasing dessert wines.

Semillon

In France, Semillon is second in importance among white grapes only to Ugni Blanc, the primary grape used in Cognac. Semillon provides the acidity and backbone for France's great dry, white Bordeaux wines and for the luscious, sweet, ultra-expensive Sauternes.

Often blended by adding Sauvignon Blanc for more complexity and balance, Washington Semillon is the state's best fish and shellfish wine. Good Washington Semillon is crisp, with aromas and flavors of lemon and/or grapefruit, melon, and fig, all tempered by

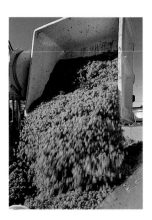

slight herbaceousness. As it ages, Semillon takes on floral and beeswax aromas, with a hint of honey, a slight nuttiness. It becomes smooth on the palate, but retains a backbone of crisp acidity that holds it together structurally for up to twenty years.

As a thin-skinned grape, Semillon is susceptible to rot—but when this is the "noble rot" produced by the mold *Botrytis cinerea,* winemakers are very pleased. A sweet, late-harvest Semillon or Semillon/Sauvignon Blanc blend that has been touched by *Botrytis* is truly a treat. The mold gives the wine a deep, honeyed creaminess on the palate and a memorably pleasant treacle or toffee-like aftertaste. Brian Carter at Washington Hills Cellars is one of a handful of Washington winemakers to make dessert-style Semillon.

At Columbia Winery, David Lake has continued a tradition of producing fine Semillons that goes back to the winery's days as Associated Vintners. Chateau Ste. Michelle, Chinook Winery, and The Hogue Cellars have

Above: Grapes are dumped into a crusher-stemmer at Columbia Crest Winery. *Right:* Automated bottling lines fill and cork hundreds of bottles of wine per hour.

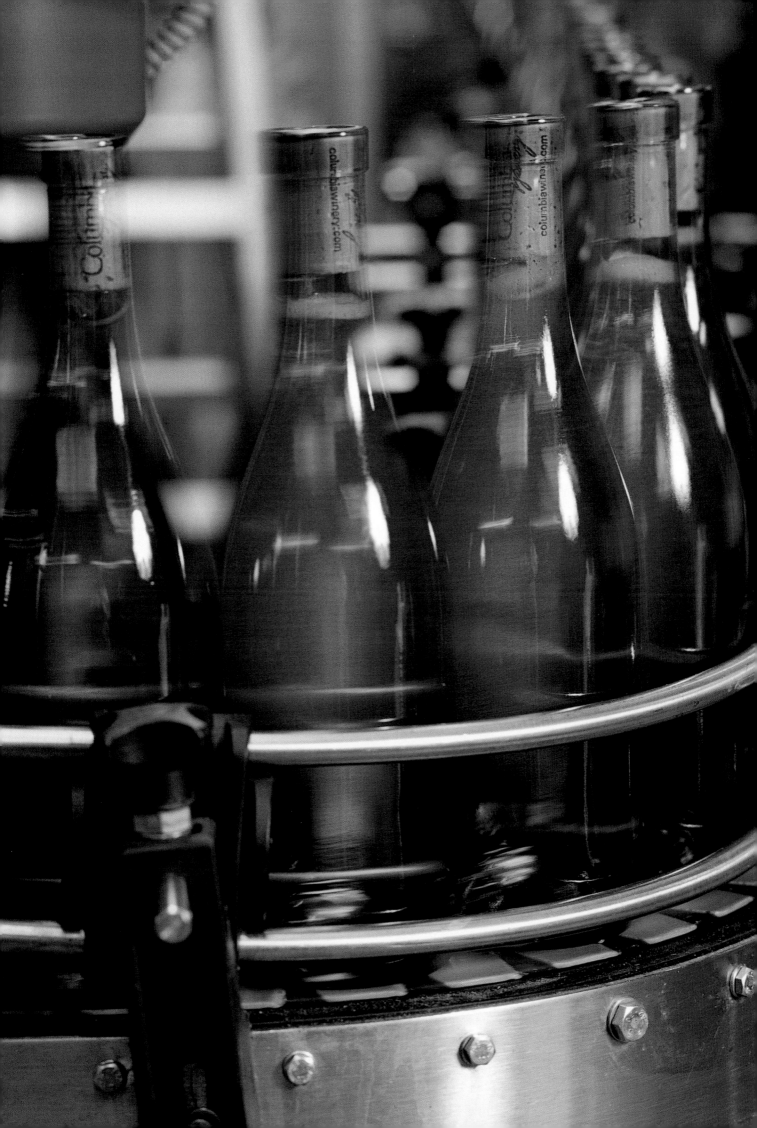

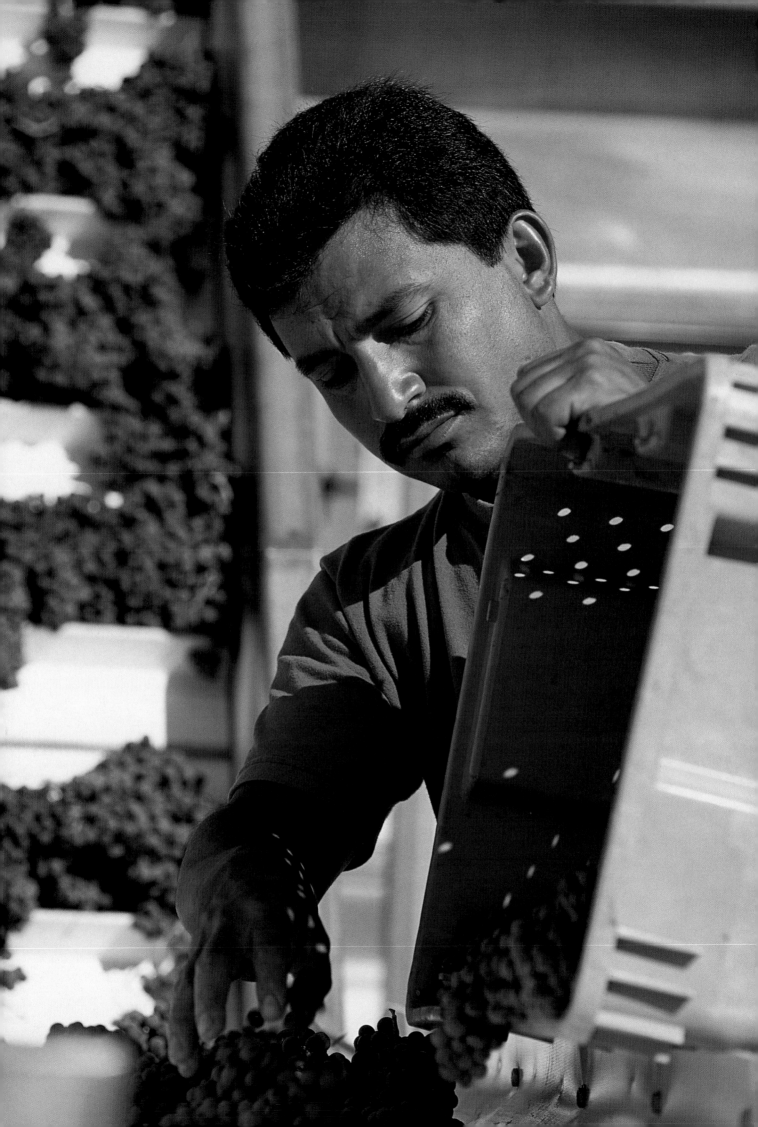

made lovely Semillons over the years. At Columbia Crest, Doug Gore followed the Australians' lead to make Washington's first Semillon-Chardonnay, an easy-drinking, food-friendly wine.

What to serve with Semillon? Look to Northwest waters for razor clams, pink singing scallops, shrimp, steamed mussels or clams, oysters on the half shell or baked with a sauce, salmon, halibut, sushi. Semillon is delicious with Vietnamese and Thai dishes, too. A sweet, late-harvest Semillon is not just for dessert. Enjoy it with *foie gras*, pâtés, and terrines.

Also Growing in Washington

Chenin Blanc, a native of France's Loire Valley, makes refreshing, fruity-floral, off-dry white wines that are high in acid and widely appealing as sippers or with a range of foods. For all its promise in Washington, Chenin Blanc lost ground due to overcropping in the vineyard, and was made primarily as a quick-to-market, cash-flow wine. The grape also has a tendency to take a beating during harsher Washington winters.

Several Washington wineries, including The Hogue Cellars, continue to carry the Chenin Blanc torch and make consistently appealing wines year in and year out. Due to relatively high yields and charm in its youth, Chenin Blanc can be made fairly inexpensively. It is a delightful accompaniment to shellfish, Thai food, sushi, and light fish such as sole.

Gewürztraminer has a checkered history in Washington. When famed California winemaker Andre Tchelistcheff pronounced a late-1960s Gewürztraminer from Associated Vintners "the best I've tasted in the United States," he created a monster, spurring a great deal of activity in the state. Unfortunately all Gewürztraminers are not equal, and most of those made in Washington during the 1970s and 1980s were a far cry from the intense, dry, spicy white wine Tchelistcheff lovingly swirled in his glass. When it's not dry and spicy, Washington Gewürztraminer tends to be sweetish, watery, and bland, with the aroma of composting roses. Unfortunately only a few Washington winemakers pursued the dry style, and Gewürztraminer sales were sluggish.

Today, with only a few hundred acres of Gewürztraminer in Washington, more winemakers are exploring the dry, beautifully food-friendly style. Chances of success are good. Gewürztraminer is quite cold resistant. And during Eastern Washington's long, dry season, Gewürztraminer properly sited should be able to hang reasonably late into its cycle, building sugars, complexity, and the acidity that makes for an interesting and long-lived wine. Enjoy one of Washington's dry, aromatic Gewürztraminers with pork, spicy sausage, Thai dishes, trout, *foie gras*, or *choucroute garni*. The occasional sweet, late-harvest Gewürztraminer makes for very special sipping after a good meal.

Left: Jose Silva gently handles Merlot grapes at Chinook Winery, Prosser.

Doug McCrea
McCrea Cellars, Rainier

Doug McCrea was born in New Orleans in a household that nourished him with fine cooking, fine wines, and music. His family moved to the San Francisco Bay Area, where he studied music, eventually enjoying a career as a music educator and jazz musician. At the same time, he honed his appetites for fine wine and food by visiting the wineries of Napa and Sonoma Counties with his family.

McCrea moved to Washington in 1980. He worked at Puget Sound–area wineries, took short courses in winemaking at the University of California at Davis, and in 1988 founded McCrea Cellars.

Though his first success was a luscious, layered Chardonnay, McCrea quickly gravitated toward the Rhone varietals. A delicious Grenache was followed by Tierra del Sol (a blend of Syrah and Grenache), Syrah, and most recently the Rhone white, Viognier.

It took McCrea several years to convince a handful of growers that these varieties could survive in Eastern Washington's harsh environment. The key, he says, is careful site selection. The grapes come from hotter than average sites with excellent air drainage and soils low in nutrients.

The first Washington winery to focus on Rhone varietals, McCrea Cellars produces only about 2,500 cases of wine yearly, 1,000 of which are an intense Syrah. In the winery, Doug McCrea emphasizes gentle gravity processing of the grapes in small batches. Use of modern technology is minimal. Despite its success, McCrea Cellars remains small, allowing the winemaker to focus on distinctive, handcrafted wines.

MCCREA

Norm McKibben
Pepper Bridge Vineyards and Winery,
Walla Walla

Norm McKibben's interest in wine was piqued when, as president of a heavy construction company, he sampled many of the world's fine wines during his business travels. He says he moved to Walla Walla to retire; if that's the case, it has been a busy retirement.

In the early 1980s, McKibben invested in The Hogue Cellars and is still one of its minority partners. For many years he owned a small vineyard outside Waitsburg. He and some partners began planting grapes on Canoe Ridge, then in 1989 sold half their interest to the Chalone Wine Group, and the vineyard became a huge enterprise. They also are partners in the Canoe Ridge Winery in Walla Walla.

McKibben began planting what is now Pepper Bridge Vineyard in 1991. "For years we sold grapes to Leonetti, Woodward Canyon, L'Ecole No. 41, and Andrew Will Cellars," he says. In 1998, McKibben decided it was time to begin producing world-class red wines of his own from the vineyard so cherished by other winemakers.

Pepper Bridge Winery will release its first wines from the 1998 vintage in spring 2001. It plans eventually to produce about 10,000 cases a year. "But we plan to grow slowly," McKibben says.

McKibben, a partner, and several minority investors own Seven Hills Vineyard in Oregon. Pepper Bridge and Seven Hills currently provide grapes to thirty-five Washington wineries.

McKibben is chairman of the Washington Wine Commission.

PEPPER BRIDGE

Cabernet Franc has long been regarded in France as a blending grape, but it is also the principal ingredient in Chateau Cheval Blanc and therefore not to be despised. In recent years Cabernet Franc has established a foothold in Washington, where it is useful in Cabernet Sauvignon/Merlot blends. Rather lean and astringent, Cabernet Franc will add power to a luscious, forward Merlot and can be useful in softening and imparting flavor dimensions to a particularly hard-edged Cabernet Sauvignon.

Cabernet Franc also has gained favor on its own, adding another serious red to the Washington portfolio. Cabernet Franc is a cold-resistant grape, which is a blessing to growers. The wine's aromas and flavors range from raspberry and blueberry to mellow coffee, pencil shavings, even violets.

Lemberger is one of those red varieties that immediately felt at home in Washington. Only a hundred or so acres are planted in this grape, but they result in some tasty reds, ranging from the light, drink-now

Beaujolais style to intense, inky, barrel-aged wines more akin to Zinfandel.

One of the first producers of Lemberger in Washington was Kiona Vineyards, where winemaker Scott Williams finds it a successful grape. Kiona's Lemberger is at the Zinfandel-like end of the scale. Another pioneer Lemberger producer, Covey Run, makes its Lemberger in a light, fruity style. Both styles are easy drinking, and easy on the pocketbook. With its cherry fruit taste laced with nuances of freshly ground black pepper, Lemberger is a perfect barbecue wine. Because it appeals to a wide range of tastes, it also fares well at the Thanksgiving table.

Above: Increasingly popular Cabernet Franc adds dimensions of flavor and complexity to Washington state's Cabernet Sauvignon and Merlot blends. *Right:* A bubbly foam appears on crushed red winegrapes, telling the winemakers that active fermentation has begun. As the must continues to ferment, it warms and bubbles, releasing carbon dioxide. Grape skins float to the top and need to be punched down at regular intervals so they stay moist and in contact with the fermenting juice. As alcohol levels build, flavors and color are extracted from the skins. The skins are later discarded, and the wine is put into barrels to finish fermentation and to age before bottling.

Many other significant varieties are in production in Washington on a limited scale. **Zinfandel** is a red made by only a handful of wineries. Barnard Griffin makes a fine one; the grapes come from Hell's Gate Vineyard near Maryhill at the east end of the Columbia Gorge. **Grenache**, a red Rhone variety, shows great promise in wines made by McCrea Cellars and Chateau Ste. Michelle.

Italian red varieties have attracted attention in Eastern Washington. Peter Dow at Cavatappi Winery made the state's first **Nebbiolo** from grapes grown at Red Willow Vineyard. Leonetti Cellars pioneered **Sangiovese** in Washington, and several other wineries tinker with it, but the jury is still out on whether the climate of Eastern Washington is right for this Chianti native.

Viognier, the principal white Rhone grape, is being tested by a number of Washington winemakers. Interest is high, with McCrea Cellars, Columbia Winery, and Waterbrook Winery leading the charge.

Members of the **Muscat** family grown in Washington include Muscat Canelli, Muscat of Alexandria, and

Black Muscat. Muscats in general produce lovely, low-alcohol, fruity-floral wines that are terrific summer sippers. The more dramatic presentations are those made in the ultra-sweet dessert style. Thurston Wolfe's Sweet Rebecca, made from Black Muscat, is such a wine.

Aligoté, a French white grape used in blending or to produce an inexpensive wine, also has found a niche in Eastern Washington. It makes a dry, light, uncomplicated wine. In Washington it was pioneered at Covey Run.

Left: The magical, mysterious Cliff House, home to Arbor Crest Wine Cellars, was restored by the Mielke family, Arbor Crest's owners, in the 1980s. The three-story mansion is perched on cliffs on a 70-acre estate east of Spokane and was built in 1924 by local inventor and eccentric Royal Riblet. In recent years this National Historic Landmark has served as tasting room and sometimes guest quarters for the winery. *Above:* Sangiovese grapes destined for Leonetti Cellars are grown in the Seven Hills Vineyard near Walla Walla. *Overleaf:* Tiny grapevines in a newly planted portion of Pepper Bridge Vineyard are surrounded by tubes to protect them from rabbits and other munching predators. Initial plantings at Pepper Bridge were in 1991; the vineyard now boasts nearly 200 acres. Grapes are sold to a number of Washington wineries. In 1998, Pepper Bridge made its first wines. They are slated for release in 2001.

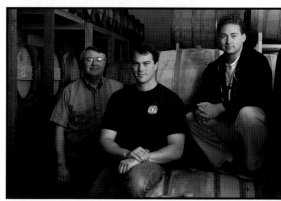

QUILCEDA CREEK

Alex Golitzen, Marv Crum, and Paul Golitzen
Quilceda Creek Vintners, Snohomish

The wine world was surprised when Alex Golitzen's first commercial wine, the Quilceda Creek 1979 Cabernet Sauvignon, won one of the few grand prizes at the Pacific Northwest Enological Society competition in Seattle in 1983. Given the story behind the story, it needn't have been. Not only was Golitzen a chemical engineer whose background gave him a good basic understanding of wine chemistry, but he also had made noncommercial wines for several years. Like Gary Figgins, he was passionate about making a limited quantity of Washington red, and he also had a wine-savvy relative to guide him.

In Golitzen's case that relative was his uncle, André Tchelistcheff, the Russian-born "dean of American wine," who was responsible for Beaulieu Vineyards' revival in Napa Valley in the 1960s. During the 1970s and until his death in 1994, he consulted with Chateau Ste. Michelle, setting its direction for the fine wines it produces today. Tchelistcheff's advice and encouragement had a profound effect on Golitzen and his wines.

Golitzen kept his day job at Scott Paper and made wine in his spare time in a small building adjacent to the Golitzen home in Snohomish. He purchased grapes from top vineyards in the Red Mountain and Zephyr Ridge regions of Eastern Washington. His fame as a winemaker grew.

Today Alex Golitzen is retired from Scott and can passionately pursue his art. His son, Paul, is in charge of day-to-day operations and has proven himself a gifted winemaker as well. Marv Crum, Alex's son-in-law, serves as assistant winemaker. The wines, in response perhaps to market preferences but also to Paul's deft touch, are a bit softer and more supple these days—more balanced, more approachable, but still worthy of aging and among Washington's best.

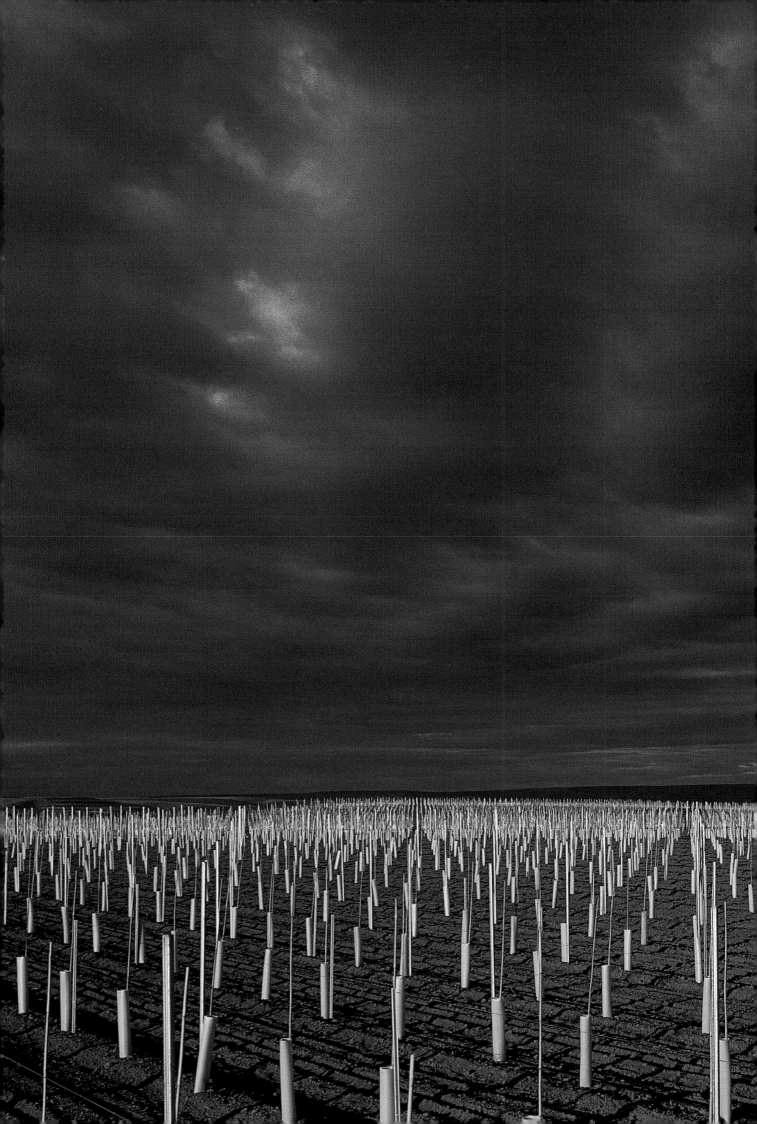

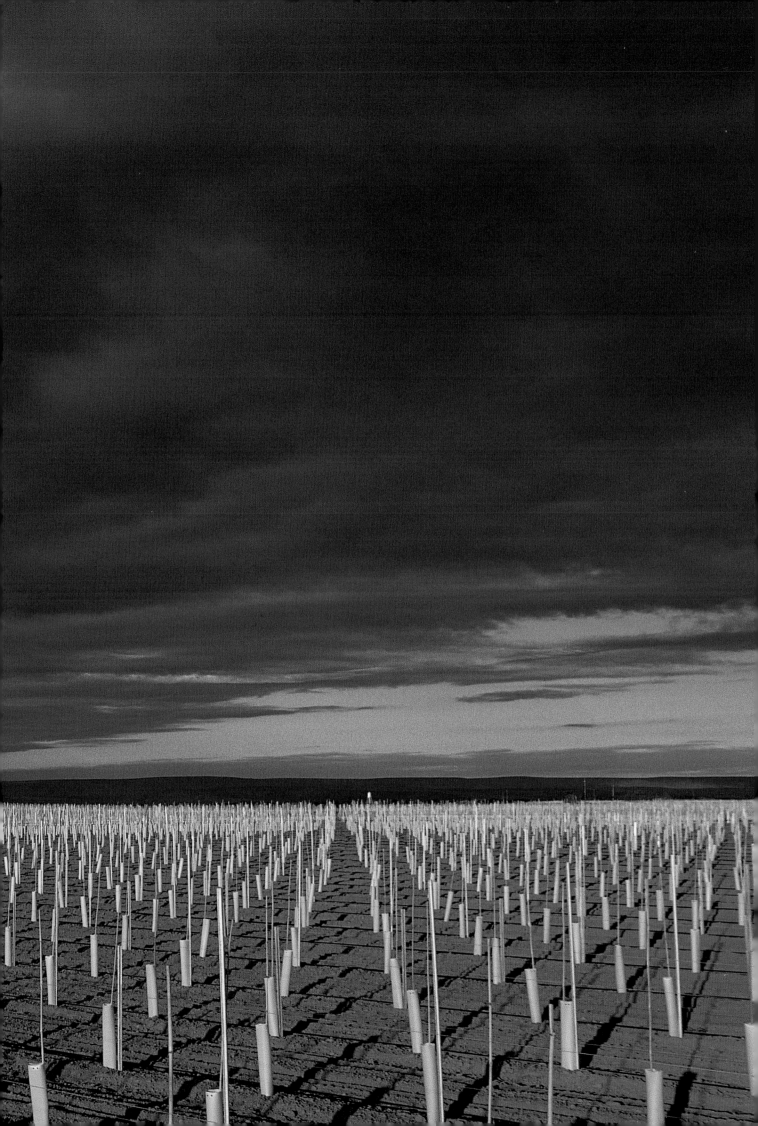

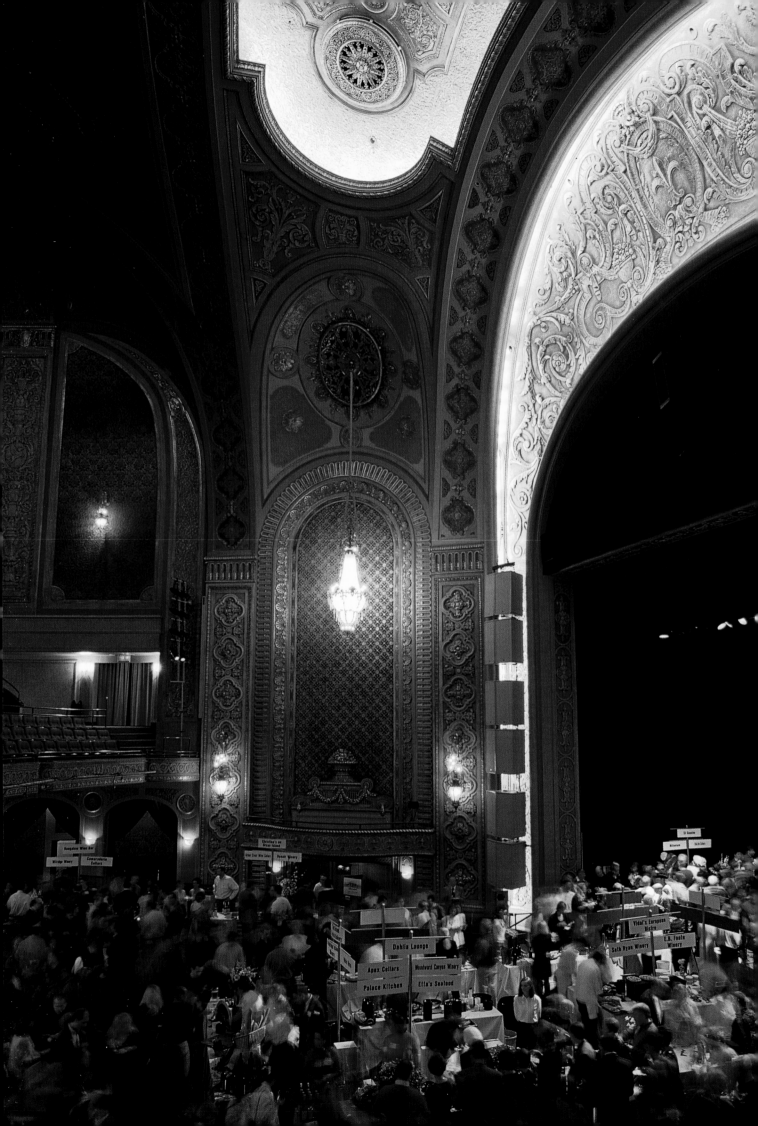

The Winemakers
of Washington

While almost all of Washington's premium winegrapes are grown east of the Cascade Mountains, the modern-day wine industry in the state got its start in the Seattle area. The winemakers began their work rather quietly, but a momentum built. More and more people—some of them idealists, dabblers, college professors, farmers—became fascinated with winemaking and took a stab at producing their own wines. The industry began with the land, but it was built by people.

It was in 1951 that Lloyd S. Woodburne, a psychology professor at the University of Washington, first started thinking about making wine. Woodburne was recovering from a family vacation and a bad case of poison oak when he picked up an old book on winemaking. He was intrigued. He called his friend Angelo Pellegrini, an Italian immigrant and an English professor at the university.

"I asked him how difficult it was to make wine at home," Woodburne recalled in a historical essay.

"It's as easy as boiling an egg," Pellegrini replied.

"He was quite wrong, as I was to learn over the next three years," Woodburne continued, "but I was hooked and made my first batch of wine that fall. It was pretty poor stuff. . . ." His wife flatly refused to drink it.

Woodburne was joined by several friends and the winemaking continued and improved. The group purchased grapes from the grape train, which brought Zinfandel to Seattle from California and sold it to home winemakers. Over the years they searched for better grape sources, and found them east of the mountains.

They purchased Riesling and Semillon from Bill Barnard, nephew of wine pioneer W. B. Bridgman. They bought Pinot Noir from George Thomas at Santa Rosa Winery, successor to Bridgman's Upland Winery. They purchased Grenache from American Wine Growers.

When the folks at Santa Rosa Winery and American Wine Growers tasted the amateurs' wines—and discovered what good wines could be made from their grapes—they decided to keep the grapes for themselves.

Joan Wolverton and Chardonnay
Salishan Vineyards, LaCenter

While they truly are veterans in the Washington wine industry, Joan and Lincoln Wolverton and their Salishan Vineyards are not in the mainstream of Washington viticulture and enology. This is because the winery and vineyards are in southwestern Washington in a climate that more resembles Oregon's Willamette Valley.

Although the vineyard and winery were her husband's idea, it's Joan who runs the show. "He always had this dream to have a vineyard and winery," she explains. "And he thought this area was like France."

After their children were born, Joan chose homemaking and winemaking duties while Linc started an economics consulting business. They began planting their vineyard in 1971 and the winery was established in 1977.

The wines Salishan produces are more akin to Oregon's. The focus is on Chardonnay and Pinot Noir. Gone are the Riesling and dry Chenin Blanc that Joan loved to make. "They were fun, but not profitable," she says.

A serious illness a few years back caused Joan to rethink her direction in life. She cut back Salishan's production to a more manageable amount and hired more help.

Life at Salishan has changed a good deal over the years. Vineyards that once bordered Salishan have been torn out, and a 400-house subdivision has taken their place. The city limits are at the Wolvertons' property line.

"It was so beautiful out here, so bucolic," Joan remembers. "Now I look out on houses."

Left: The old Paramount Theatre in downtown Seattle sparkles with excitement at the 1999 Taste Washington: A Celebration of Wine and Food. The annual event, held in the spring, features Washington winemakers and chefs pairing local wines with regional dishes—a tasting event not to be missed.

Cheryl Jones
SilverLake Winery, Bothell

*Like so many of Washington's wine luminaries,
Cheryl Jones (nee Barber) got her start at
Chateau Ste. Michelle. Recently graduated from
college with a degree in food science, she
intended in 1976 to work in the dairy industry.
But she answered an ad for office work at
Chateau Ste. Michelle and ended up working
in the winery's laboratory that she set up.*

*"I was the only girl there," she remembers,
"and they didn't even have a laboratory." So
she set one up in the women's restroom. She
trained with then-winemaker Joel Klein. In
1982 she became assistant winemaker and
began tasting wine on a regular basis with
the winery's consultant, Andre Tchelistcheff.
By the time Jones left in 1988, she was
Chateau Ste. Michelle's head winemaker.*

*Jones then was able to spend more time
with her baby daughter, but she kept connected
by consulting for such wineries as Badger
Mountain and Paul Thomas. Then in 1991 the
phone rang; it was her friend and colleague
Brian Carter. "He asked me if I could work one
day a week," she says. "What's not to like about
that?" Thus began her career as winemaker
at SilverLake Winery.*

*Jones has seen the winery grow from
3,000 to 30,000 cases a year. The winery
has acquired vineyard land and a facility
near Zillah, where all the red wines are now
made. SilverLake's emphasis is reds, primarily
Cabernet and Merlot. Jones is developing a
reserve program, whereby the best barrels of
wine are held back, or reserved, for additional
aging and later release. She also plans to
experiment with Italian red varieties as
SilverLake develops its new vineyard.*

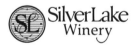

Ten members of the Woodburne group incorporated
and bonded in 1962 to form Associated Vintners. They
bought five and a half acres near Sunnyside from
Bridgman and obtained cuttings from the University of
California at Davis. In 1963 they planted Gewürz-
traminer, Riesling, Semillon, Chardonnay, Grenache,
and Cabernet Sauvignon. All good choices, it turned out.

When Andre Tchelistcheff, winemaker at Beaulieu
Vineyards in Napa Valley, visited American Wine
Growers in 1967, he managed a short visit to the
Woodburne garage. Lloyd Woodburne called his partner
Phil Church, who invited them over and poached a
salmon for supper. With it the vintners served one of
Church's homemade Gewürztraminers.

"Where did you get that wine?" Tchelistcheff
demanded.

Church was about to take offense when the great
Russian-born winemaker continued, "This is the best
Gewürztraminer made in the United States."

Meanwhile, American Wine Growers was buying
grape land in Eastern Washington. In 1955 it bought a
vineyard that already contained numerous grape vari-
eties, including Sauvignon Blanc, Muscat of Alexandria,
Grenache, and Semillon. It purchased a large Concord
vineyard near Benton City and planted 15 acres of Caber-
net Sauvignon there. And it acquired one of Bridgman's
vineyards that contained a wild assortment of grape
varieties and proved a good place to experiment.

By the mid-sixties, American Wine Growers was
ready to focus on serious varietal wines. The winemaker
was Howard Somers—son of Charles Somers of St.
Charles Winery, the Stretch Island winery that was
bonded right after Prohibition. American Wine Growers
planted a vineyard at Hahn Hill in Eastern Washington
and began marketing some of its wine under the name
Ste. Michelle Vineyards.

The Ste. Michelle brand was launched in 1967 with
European-style varietal wines. The Semillon, Cabernet
Sauvignon, and Grenache were made under direction
of Andre Tchelistcheff, the winery's consulting enolo-
gist. Washington's direction as an emerging producer of
premium wines was set.

These developments were taking place at a time
when Washington was still Concord grape country. At
the end of the '60s, Concord grapes accounted for nearly
9,500 acres of the state's roughly 10,500 acres of vine-
yards, with most of the fruit going into juice and jellies.

Right: The thick trunks of venerable grapevines at Sagemoor
Vineyards bear witness to Sagemoor's early days dating from the
mid-1970s. The vineyard was started by Seattle attorney Alec
Bayless and a group of investors. Today, many of Washington's
top wineries lease small blocks within the vineyards. These
blocks are then maintained to the lessee's specifications.

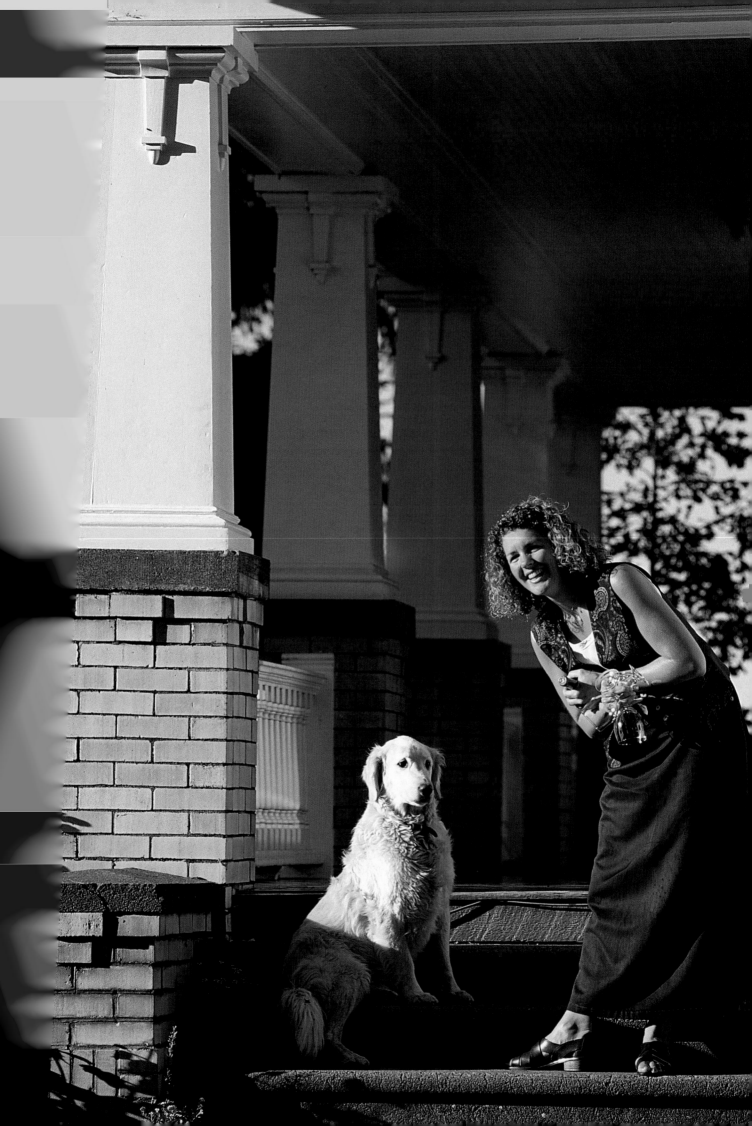

Premium winegrapes accounted for only 431 acres in 1970—and if people thought about Washington vineyards at all, they visualized them as somehow synonymous with grape juice.

This was changing. The increasing demand for classic European grape varieties encouraged Eastern Washington grape growers. Vineyards went in at Dallesport, the Wahluke Slope, Alder Ridge, and Cold Creek. The largest early plantings in the Columbia Valley came between 1968 and 1972 when Vineyard Management Company planted more than 1,000 acres of premium winegrapes at Sagemoor Farms, overlooking the Columbia northwest of Pasco. Columbia Valley winegrapes had become big business.

The 1970s: A New Look

Quietly the Washington wine industry grew. There was not much hoopla during the 1970s, but the decade that had begun with barely 400 acres of premium winegrapes ended with 3,000.

In San Francisco in 1970, a Safeco Insurance Company portfolio manager named Wally Opdyke read about Washington wines in the *Seattle Post-Intelligencer*, and something clicked. He contacted horticulturist Walter Clore and later in 1970 visited Eastern Washington for a vineyard tour. Opdyke knew little about wine, but he knew a lot about finance.

Opdyke contacted American Wine Growers, which at the time was Washington's only viable winery besides the tiny Associated Vintners. By that time the owners of American Wine Growers were aging; the

Allen Shoup (right), pictured with Piero Antinori
Stimson Lane Vineyards and Estates, Woodinville

A native of Michigan, Allen Shoup earned degrees in business administration and psychology before taking his first position in the wine business—as a marketing manager with E&J Gallo, in Modesto, California. Shoup became president of Stimson Lane in 1984, and since then his presence in the wine industry has become legendary.

Shoup is a founder of the Washington Wine Institute and is lead director of the Washington Wine Commission. He serves on the boards of the American Vintners Association, the American Center for Wine, Food and the Arts, and several charitable groups. He is a founder of the Auction of Northwest Wines, which has raised millions of dollars for Children's Hospital in Seattle, and is a driving force behind Seattle's biennial World Vinifera Conference.

"Allen is one of the true visionaries in the American wine industry," says Steve Burns, executive director of the Washington Wine Commission. "His generosity and leadership in the Washington wine industry and in California is without equal."

Shoup conceived a joint project with famed Tuscany winemaker Piero Antinori in which Antinori and Chateau Ste. Michelle winemaker Mike Januik made red wine from Washington grapes. The first Col Solare—Italian for "shining hill"—wine was made in 1995.

Stimson Lane owns and operates Chateau Ste. Michelle, Columbia Crest, Snoqualmie, and Domaine Ste. Michelle wineries in Washington and Villa Mt. Eden and Conn Creek wineries in the Napa Valley.

Left: Vanessa Finch and Dusty greet guests from the stately porch of the Mill Creek Inn near Walla Walla. The bed-and-breakfast inn occupies the historic Kibler-Finch Homestead. The land around the Inn is planted with grapes for the newly established Titus Creek Winery. The carriage house at the estate is home to Glen Fiona Winery. *Above:* Testing is ongoing in winery laboratories to monitor sugar, alcohol levels, pH, and acidity, and to guard against undesirable microbes.

Charlie Hoppes
Three Rivers, Walla Walla

Charlie Hoppes grew up in Wapato, Washington, but eventually moved away to college at the University of California at Davis, where he majored in agricultural science and management. What his diploma does not mention are the many enology and viticulture classes he took there. After graduation in 1988, he returned to the Northwest and worked for Snoqualmie, Saddle Mountain, and Langguth wineries before working a crush at Waterbrook.

From then, "My career mirrors that of Mike Januik," he says. Chateau Ste. Michelle hired Januik in 1990. He in turn hired Hoppes in October of that same year. Hoppes moved to Stimson Lane's River Ridge facility in 1993 and made wine there until April of 1999.

In February of 1999, Hoppes gave an address on the Washington wine industry to a local business organization. In the audience were Duane Wollmuth, Brad Stocking, and Steve Ahler, who had recently purchased the defunct Biscuit Ridge Winery and were planning to start their own venture. Hoppes left Stimson Lane to become winemaker at the new Three Rivers Winery. Ironically, Januik also left Stimson Lane in 1999 to start his own winery.

Three Rivers is located west of Walla Walla on Highway 12. The first wines were made in 1999; and the owners expect it to be producing 15,000 cases of wine by its third year. While Hoppes is at the helm as winemaker, Three Rivers owners also carry on active roles in the winery. Wollmuth is the managing partner in charge of marketing; Stocking is in charge of sales; Ahler is viticulture manager and owns a small vineyard of his own.

youngest partner, Joe Molz, was in his sixties. The partners agreed to sell out to Opdyke and an investment group, who promptly renamed the company Ste. Michelle Vintners.

Opdyke retained Vic Allison as the winery's general manager and Les Fleming as vineyard manager. Andre Tchelistcheff stayed on as a consultant. Ste. Michelle purchased 500 acres at Cold Creek, near the Wahluke Slope, and began aggressively planting classic winegrapes.

There was a problem, however. Opdyke needed more capital to finance expansion. He wrote up a business plan in 1973 and started looking for money. He was negotiating with Labatt's, a Toronto-based brewing company, when the phone rang. A representative of U.S. Tobacco said the company wanted to talk. Opdyke liked the people and he agreed with their long-term approach to the business. A deal was crafted between the two parties, and U.S. Tobacco bought the winery.

The arrangement resulted in a brand new, chateau-style winery building in Woodinville, near Seattle. When the Cold Creek vineyard was nearly destroyed in the bitter winter of 1978-79, U.S. Tobacco again assured Opdyke that it was in business for the long haul; more than 300 acres were replanted.

As the '70s ended and a new decade began, Chateau Ste. Michelle and Associated Vintners made a couple of hires that helped set the course for the companies for the rest of the century. David Lake was hired in 1979 as assistant winemaker at Associated Vintners, and with Lloyd Woodburne ill, Lake made all the wine himself. His creative winemaking has guided the company, which became Columbia Winery, ever since. At Chateau Ste. Michelle, Allen Shoup went to work as the far-seeing vice president of marketing and has remained with the organization ever since, eventually becoming president of Stimson Lane Vineyards and Estates, which includes Ste. Michelle.

On the west side of the state, several small wineries opened during the '70s, including Manfred Vierthaler Winery in East Sumner, E. B. Foote Winery in Seattle, Quilceda Creek Vintners in Snohomish, Paul Thomas Wines in Bellevue, Neuharth Winery in Sequim, and Hoodsport Winery in Hoodsport.

On the east side of the Cascades, many vineyards were being planted and a number of small wineries opened, including Hinzerling Winery in Prosser, Preston Wine Cellars in Pasco, Leonetti Cellars in Walla Walla, Yakima River Winery in Prosser, and Kiona Vineyards Winery in West Richland.

Right: Twin brothers Justin and Jason Merriman pull bottles at Woodward Canyon Winery for a summer wine tasting open house.

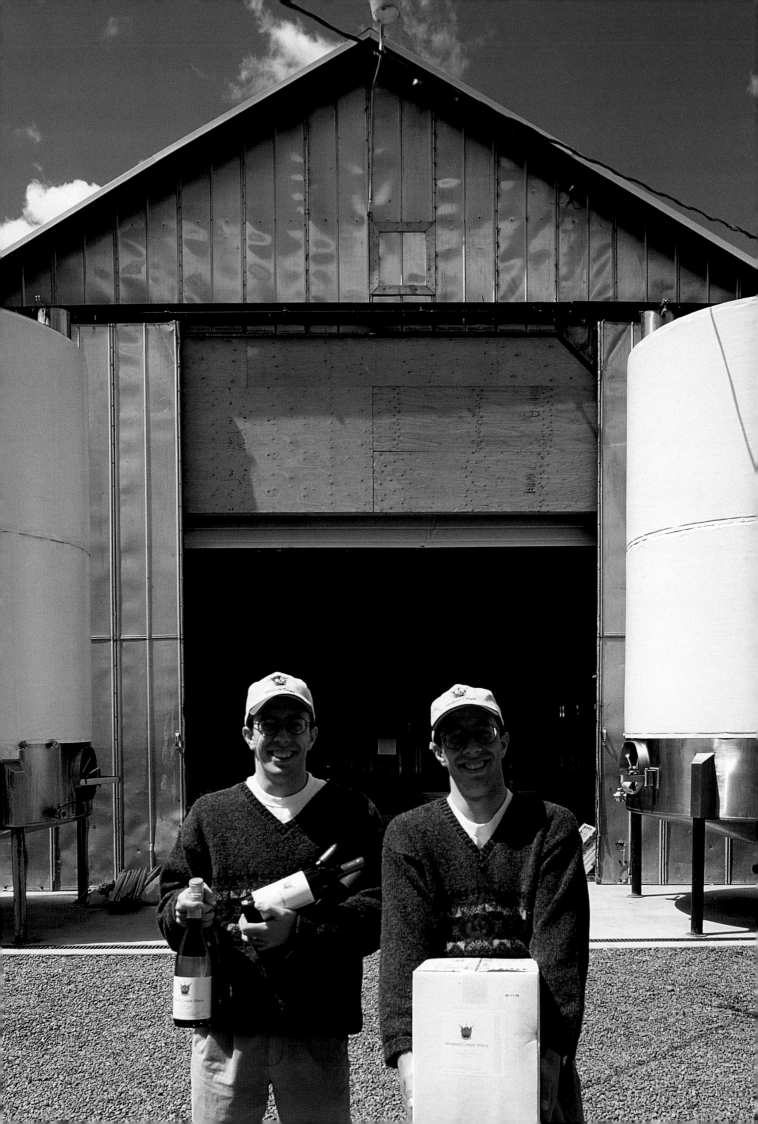

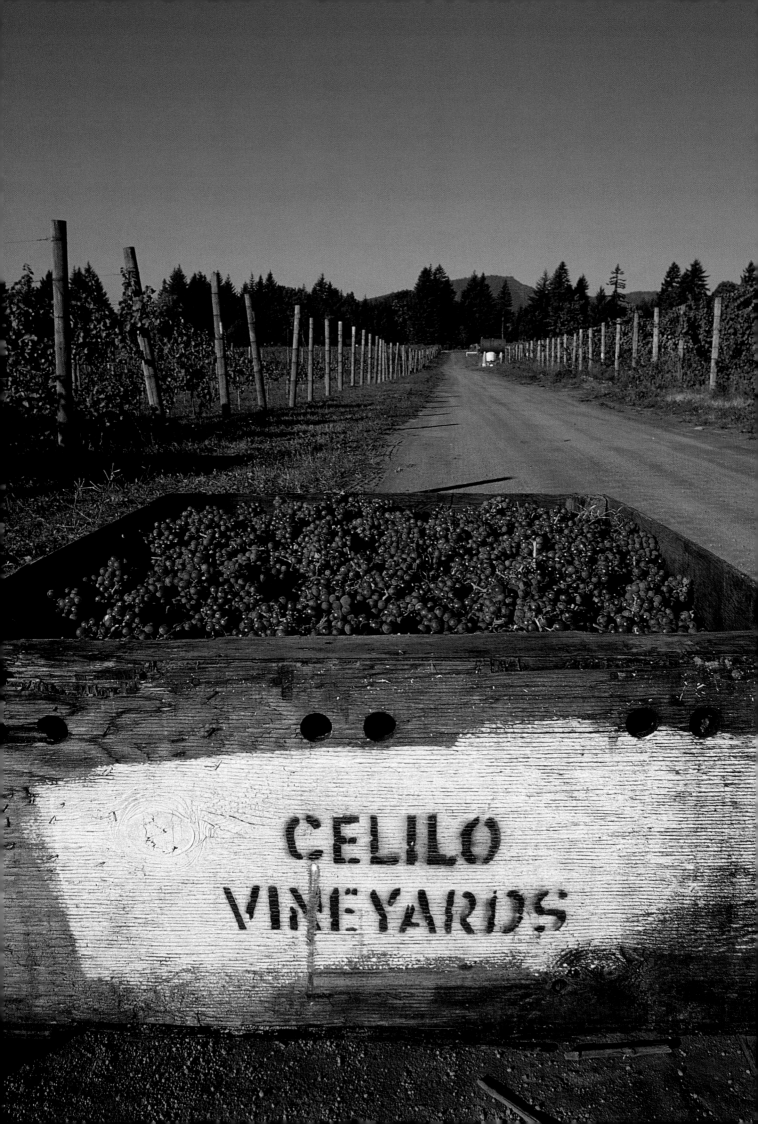

A modest building on a quiet street in Prosser became the home of Hinzerling, founded in 1976 by Mike Wallace and his father, Jerry. It was the Yakima Valley's first modern-day family winery. After a stint in the Army, Mike Wallace had heard about the work of horticulturist Walter Clore and visited him in Prosser. Wallace went on to graduate from the University of Washington and to study at the University of California at Davis. The Wallaces bought land near Prosser and planted grapes in 1972 that were then wiped out by a cold winter. They replanted in 1973, and three years later, Hinzerling produced its first commercial wines.

In the Walla Walla Valley, two influential wineries were born as Leonetti Cellars produced its first wines in 1977 and Rick Small planted the first winegrapes for the Woodward Canyon Winery that opened in 1981.

The last half of the decade saw new vineyard plantings in both Puget Sound and the Columbia Valley. In Eastern Washington, the learning curve for growers was steep. Those who planted in marginal sites were wiped

out during the first really bad winter. Those who over-cropped, and thus overstressed their vines, were often hurt by winter cold. Though the same grapes grown in California could be grown in Eastern Washington, this clearly was *not* California in the wintertime. The good growers learned that very quickly.

As Associated Vintners and Chateau Ste. Michelle began to rely on the Yakima Valley, significant new vineyards were planted. Mike Sauer developed Red Willow Vineyards on the south bench of Ahtanum Ridge; John Williams and Jim Holmes established a vineyard at Red Mountain; Mike Hogue, a grower of hops, asparagus, and Concord grapes, planted 110 acres of winegrapes; a partnership of apple growers established Quail Run Vineyards. The rush was on.

Left: Recently harvested Gewürztraminer grapes fill totes at Celilo Vineyard. Celilo is located across the Columbia River from Hood River, Oregon, and is known for its Gewürztraminer and Chardonnay, which it sells to wineries in Oregon and Washington. *Above:* Yakima Valley farmer and vineyard visionary Mike Sauer began planting Red Willow Vineyard in 1973.

Wade Wolfe
Thurston Wolfe Winery, Prosser

In addition to his duties as general manager of The Hogue Cellars in Prosser, Wade Wolfe—along with his wife, Becky Yeaman—owns the tiny Thurston Wolfe Winery located just a hundred yards from The Hogue Cellars.

Wolfe earned a bachelor's degree in biochemistry and a Ph.D. in grape genetics at the University of California at Davis. He consulted for several Northwest wineries and was director of vineyard operations for Chateau Ste. Michelle before joining The Hogue Cellars as viticulturist in 1991.

Although much of his career was spent managing vineyards, Wolfe was interested in production as well. He and Yeaman started Thurston Wolfe in 1987 in Yakima. They now are located in Prosser and produce about 1,000 cases of wine a year.

Their focus seems to be whatever they feel like at the time. A deep, delicious Lemberger and a bit of Zinfandel have always been part of their portfolio. Newer are the Pinot Gris and Viognier from grapes they grow in their own tiny vineyard. Port is made from a blend of Cabernet Sauvignon, Lemberger, and Zinfandel. Thurston Wolfe's fortified late-harvest Black Muscat, aptly named Sweet Rebecca, is a favorite with consumers and the wine press.

THURSTON WOLFE

Walla Walla Vintners

Myles Anderson and Gordon Venneri
Walla Walla Vintners, Walla Walla

Myles Anderson and Gordon Venneri have been making wine together since 1981. "We started out as home winemakers," Anderson explains. Then in 1995, Alan Jones asked them to join him in a commercial venture, and Walla Walla Vintners was born. When Jones tired of the business in 1998, Anderson and Venneri put together the funding to buy him out.

Walla Walla Vintners was the seventh bonded winery in the Walla Walla Valley, where today there are more than twenty. It produces 2,400 cases of premium red wine yearly, a blend of Cabernet Sauvignon, Merlot, and Cabernet Franc. In addition to being a winemaker, Anderson is a teaching psychologist at the local community college and Venneri is a CPA and insurance agent. "It's a hobby business for us," Anderson says, "but it is driven by some passion." Indeed, their wine—aged for fifteen months in a combination of American and French oak barrels—is anything but a hobby wine. It is one of the region's most sought after. With the 1999 crush, they made their first wine from Sangiovese grapes. They also took on the job of winemakers for Spring Valley Vineyard, a small new winery in the Walla Walla Valley.

The 1980s: The Growing Years

A great flurry of activity started the decade as more growers planted the classic European grape varieties. Vineyard Management Company planted 230 acres of winegrapes on Wahluke Slope. The Taggares family, farmers of apples, alfalfa, and potatoes, planted vines there too. The Gordon brothers grew grapes on the north side of the lower Snake River, and many more growers established vineyards in the Yakima Valley. In 1981 Washington boasted nearly 8,000 acres of European grape vineyards, although more than half of the acreage was not yet bearing.

Continuing its commitment to the industry, Chateau Ste. Michelle built a $25 million winery on River Ridge above Paterson.

Quail Run Vineyards in the Yakima Valley near Zillah crushed its first grapes in 1982 and made 30,000 gallons of wine. Led by winemaker Wayne Marcil, from California, and general manager Stan Clarke, formerly of Chateau Ste. Michelle, Quail Run quickly grew to a 100,000-gallon winery.

In Prosser, The Hogue Cellars also made its first wines in 1982—some 15,000 gallons under the direction of Mike Conway. Like Quail Run, The Hogue Cellars exemplified the family winery at a new level of professionalism, with farmers who loved the land growing their own grapes and experts in wine production and marketing running the winery. The Hogue grew quickly. The Hogues had made a fortune in hops, so the new venture was well financed. When Conway left to start his own winery, Rob Griffin became winemaker and stayed with The Hogue until the early '90s.

By the mid-1980s, Washington wineries large and small were making seriously good wine on a consistent basis. During 1983 and 1984, the federal government officially recognized three viticultural areas (appellations) in Washington State: Columbia Valley, Yakima Valley, and Walla Walla Valley. (The Puget Sound appellation wasn't officially designated until 1995.)

The early 1980s saw the opening of several wineries in Spokane, with Jack Worden's Worden Winery leading the parade. Two cherry growers—Harold Mielke and his brother David Mielke, who was also an antiques dealer—opened Arbor Crest Winery in the restored Riblet Estate high on a ridge overlooking the Spokane River. Mike Conway, Worden's first winemaker, returned to Spokane to open Latah Creek Wine Cellars.

Right: Eastern Washington's huge landmark winery, Columbia Crest, was built in 1982 at a cost of $25 million. Perched above Paterson in the Horse Heaven Hills, the winery has been expanded twice since it was built. The bulk of the facility, more than twelve acres, is underground, which affords temperature stability and conserves energy costs during extreme hot and cold weather.

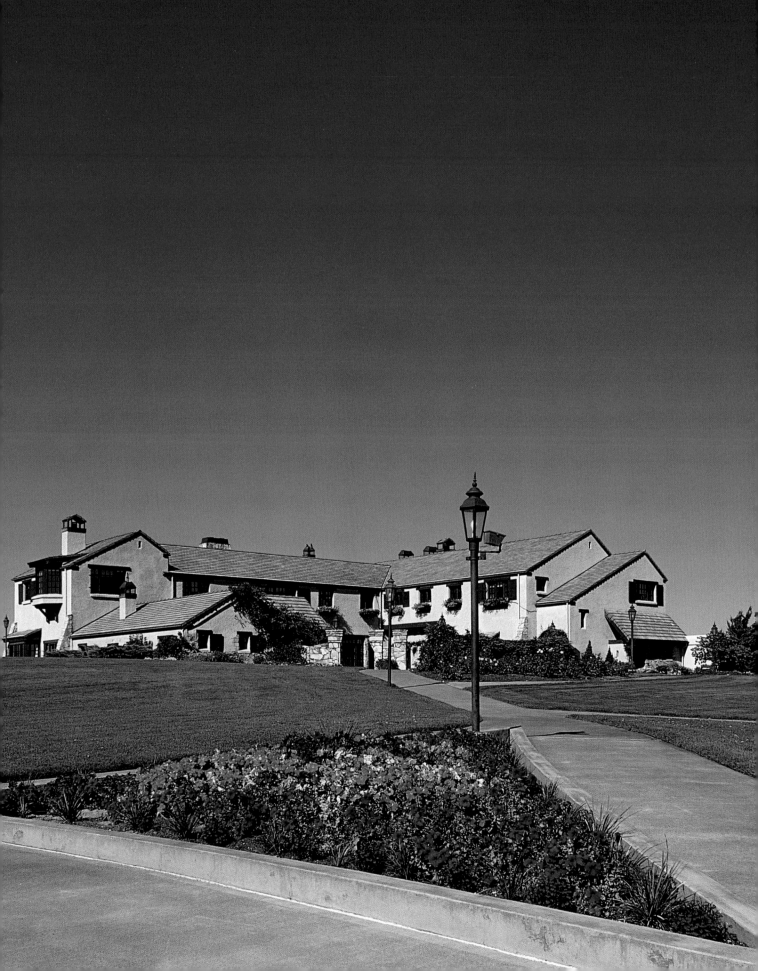

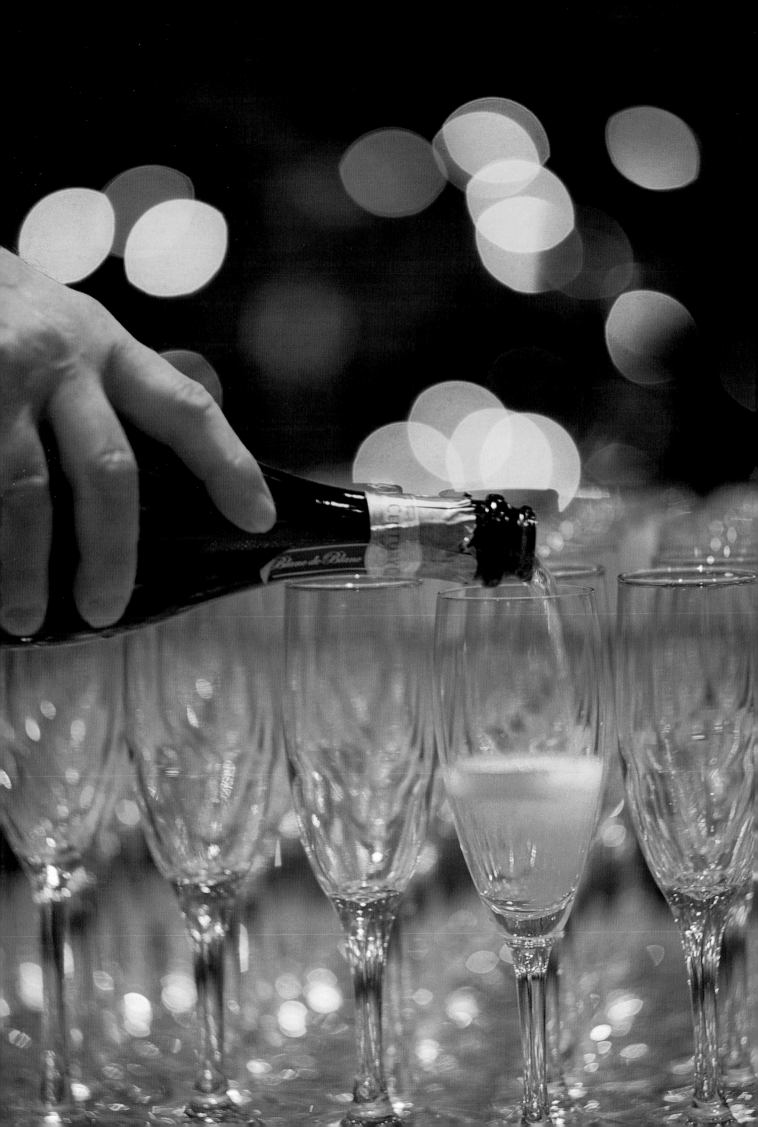

In the Walla Walla Valley, at first it was Leonetti Cellars and Woodward Canyon Winery. Then in 1983, Baker and Jean Ferguson restored the old Lowden Schoolhouse and created the winery known as L'Ecole No. 41. The following year, Eric and Janet Rindal made the first Waterbrook Winery wines in an old asparagus shed. The wineries grew and prospered, with their reds in particular gaining national attention.

The Tri-Cities area flourished with wineries too. For a while it was just Preston Wine Cellars, but in the 1980s came Bookwalter Winery, Barnard Griffin, Gordon Brothers Cellars, Balcom & Moe Winery, Seth Ryan Winery, and many others.

During the late 1980s, the focus of growth continued to be the Yakima Valley. Established wineries grew and flourished. Stimson Lane's River Ridge facility became Columbia Crest Winery, a new brand of high-quality, high-volume, moderately priced wines made by Doug Gore. Stimson Lane also launched Domaine Ste. Michelle, a sparkling wine offshoot of the company.

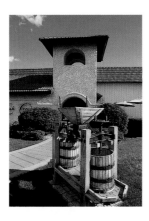

Quail Run changed its name to Covey Run Wines to avoid a court battle with Quail Ridge Vineyards in California, which took issue with its name.

In the northern Puget Sound area, Mt. Baker Vineyards specialized in delicious renderings of cool-climate varietals such as Müller-Thurgau, Madeleine Angevine, and Siegerrebe. Farther south, Bainbridge Island Winery began making wines from their own vineyard. New wineries opened in the Seattle area, including SilverLake Winery, McCrea Cellars, Soos Creek Winery, Facelli Winery, and Washington Hills Cellars.

Left: Washington sparkling wines add a festive touch to many a celebration. Backbone for these sparklers is Pinot Noir. Grown in Eastern Washington, it does not usually make a successful still wine; but picked early it provides an excellent sparkling wine base. Chardonnay and Riesling also may be used in Washington sparklers. (Only a few good still Pinot Noirs are made in Washington, and these come from small vineyards located in the Puget Sound and southwestern Washington.) *Above:* Latah Creek Winery in Spokane is owned by Mike Conway and his family. Mike began his career as a winemaker at Spokane's first winery, Worden Winery, and was The Hogue Cellars' first winemaker before founding Latah Creek.

Brian Carter
Washington Hills Cellars, Sunnyside

In his early teens Brian Carter played at wine-making, producing home brews from local fruits and berries in Corvallis, Oregon, his hometown. He later majored in microbiology at Oregon State University, then earned a master's degree in enology at the University of California at Davis.

Carter worked briefly at Napa Valley's renowned Chateau Montelena before moving to the Seattle area in 1980 as winemaker for Paul Thomas Winery. The winery's emphasis was fruit wines, and Carter crafted some of the best. During his eight years at Paul Thomas, the winery also became known for its Chardonnay, Merlot, and Cabernet Sauvignon.

After he left Paul Thomas, Carter consulted for several start-up wineries including SilverLake, McCrea Cellars, Soos Creek, Washington Hills, and Hedges. In 1990 he became a partner and full-time winemaker at Washington Hills, a large winery founded by former Seattle wine retailer and distributor Harry D. Alhadeff.

The Washington Hills label bespeaks premium quality wine in a moderate price range. Now located in Sunnyside, it also produces ultra-premium wines under the W. B. Bridgman and Apex names. The range of varieties and price categories represented enables Carter to do his best work, using technical skills that are surpassed only by his keen palate and innate talent at blending.

Carter has twice been named Washington magazine's Winemaker of the Year. In 1996 industry peers gave him the Alec Bayless Award. Named for the late founder of Sagemoor Vineyards, this is the highest honor given by the Washington wine industry.

WATERBROOK *winery*

Eric Rindal
Waterbrook Winery, Lowden

In the early 1960s, says Eric Rindal, his was the only Scandinavian family he knew of that actually drank wine. He allows that his mother's Swiss heritage had something to do with the fact his family regularly enjoyed wines at the dinner table. Later, when he was working in Anchorage, Alaska, he and friends formed a wine-buying club. "At the time, all the planes from the world's wine-producing regions stopped in Anchorage," he explains. The choices were almost limitless.

Eric met his wife, Janet, on the ski slopes of Sun Valley. Janet lived in Walla Walla and knew Baker and Jean Ferguson. When the Fergusons started their winery, L'Ecole No 41, they hired Eric and Janet as cellar help. Working L'Ecole's first crush, the Rindals knew what they wanted to do.

Waterbrook's first wines were made in 1984. The winery grew slowly from its initial 2,200 cases to its current level of 20,000 to 25,000 cases yearly. Today most of their red grapes come from the Red Mountain subregion in the Yakima Valley, while the Chardonnay is grown in the Walla Walla Valley.

Like his Walla Walla Valley predecessors, Eric is a self-taught winemaker. Kay Simon consulted for the winery during its first year, and Eric was a frequent beneficiary of the wisdom of neighboring winemakers Baker and Jean Ferguson, Rick Small, and Gary Figgins.

"Nobody else here had any formal training. We shared information and equipment. It was a great time to start." Waterbrook was the fourth winery in the Walla Walla Valley.

Associated Vintners closed a chapter in its history and began another. By 1984 several of the original partners had died, the rest were elderly. Capital was needed for equipment, a larger facility, a new look—in short, an overhaul. An investment group headed by Seattle lawyer Dan Baty restructured the company and the winery got a new name. Associated Vintners became Columbia Winery, and in 1987 the winery moved into the defunct Haviland Vintners' large, nearly new facility in Woodinville.

The 1990s: An Industry Matures

During the 1990s, many established wineries were absorbed by larger ones. Investors arrived on the scene who had the money to take on big projects. Although it got a little more difficult, the small guy still was able to start a winery and not only succeed, but thrive.

Perhaps most important for Washington during the 1990s is that it evolved from a state known for its white wines to a state known for its reds. Sure, the whites—Chardonnay, Semillon, Sauvignon Blanc, and Riesling—are still wonderful, and in many instances superlative. But the reds have taken center stage: Cabernet Sauvignon, Merlot, Cabernet Franc, Lemberger, Grenache—and most recently Syrah, with some 3,000 acres now planted to this grape.

The two principal movers in acquiring existing wineries were Stimson Lane, the company that owns Chateau Ste. Michelle and Columbia Crest Winery, and Columbia Winery, the former Associated Vintners.

Stimson Lane purchased the floundering Snoqualmie Winery and its production facility in Mattawa that once was the German-owned F. W. Langguth Winery. The company also bought vineyard land on Canoe Ridge and built a new red-wine facility at the site.

Columbia Winery purchased the Paul Thomas Winery and moved it from Woodinville to a new 400,000-gallon-capacity winery near Sunnyside. Columbia and Paul Thomas began selling under the name of Corus Brands, which added Covey Run and Idaho's Ste. Chapelle Winery to its portfolio.

The California-based Chalone Wine Group bought vineyard land on Canoe Ridge and opened a new winery in a historic brick engine house on the western edge of Walla Walla. John Abbott of Chalone's Acacia winery in California came to Washington as winemaker.

Right: At Columbia Crest Winery, huge stainless steel fermentation and barrel storage facilities are housed underground, where the wines can be more easily protected from temperature extremes.

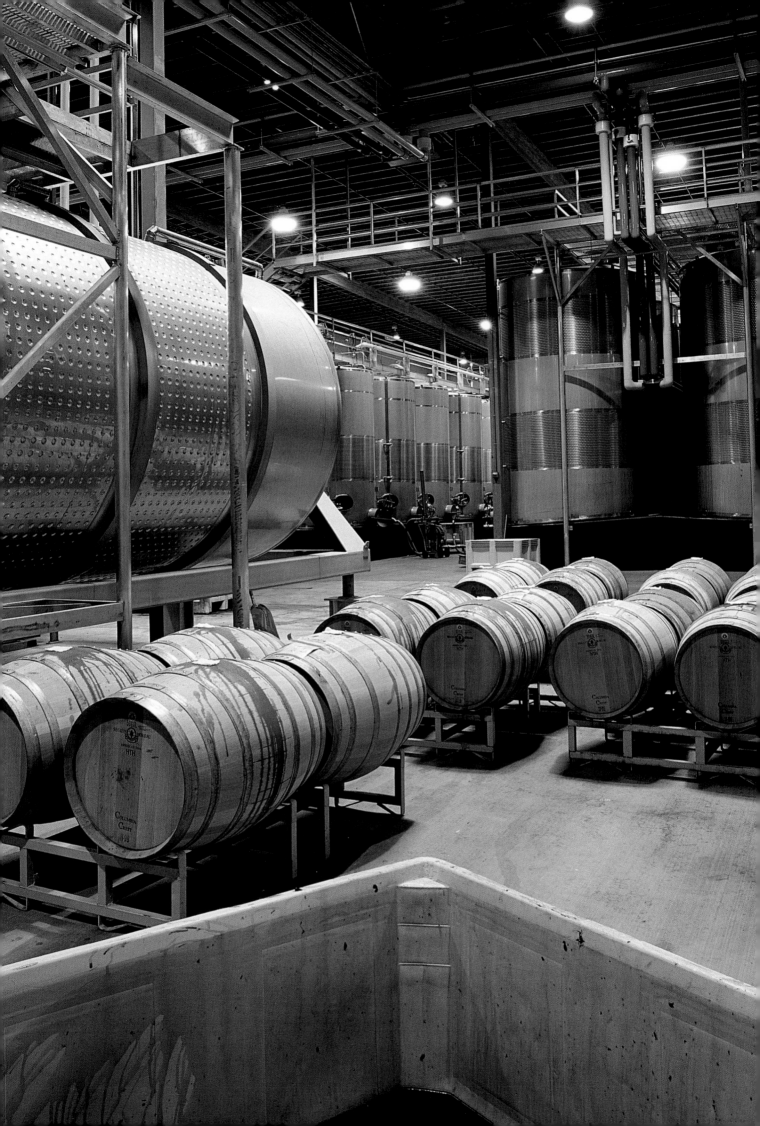

Chalone's Canoe Ridge venture, plus the success of such wineries as L'Ecole No 41, Leonetti Cellars, Waterbrook Winery, and Woodward Canyon, generated a rush in the Walla Walla Valley. At the beginning of the decade there were seven Walla Walla Valley wineries; by the end, there were more than twenty.

In the Seattle area, SilverLake Winery began building a new sparkling-wine facility in Woodinville. Bainbridge Island vintners JoAnn and Gerard Bentryn worked tirelessly through the federal bureaucracy and succeeded in having Puget Sound recognized as Washington's fourth official viticultural area (appellation).

Small wineries sprang up everywhere. DeLille Cellars crushed its first grapes in Woodinville in 1992. Producing only a couple of thousand cases a year, DeLille's Chaleur Estate focuses on small production of Bordelais-style wines using fruit from selected blocks of several of Washington's premier grape estates, including the old Bridgman property near Sunnyside.

Gordon Brothers expanded and hired a charming

French winemaker, Marie-Eve Gilla. The Hogue Cellars doubled its size. Columbia Crest added space. Washington Hills Cellars restored an old creamery in Sunnyside and moved from Seattle to be closer to its grape sources.

Tom Hedges broke new ground by establishing Hedges Cellars. Founded in Issaquah in Western Washington, the winery's first mission was to export affordable, good red wine—a Cabernet-Merlot blend—to a client in Europe. Once established as an exporter

Above: DeLille Cellars co-owner Greg Lill and friends enjoy a lovely summer afternoon at Roche Harbor in the San Juan Islands. *Left:* The old Lowden Schoolhouse (No. 41) was tranformed into L'Ecole No 41 Winery in 1983 by then-owners Baker and Jean Ferguson. It was the Walla Walla Valley's third modern commercial winery. The winery, now owned and operated by Marty and Megan (the Fergusons' daughter) Clubb, is a local landmark. It gained national attention when Marty took over winemaking duties. Marty has generously shared his winemaking knowledge with several up-and-coming winemakers who now have wineries of their own.

Rick Small
Woodward Canyon Winery, Lowden

Following closely at the heels of his friend Gary Figgins of Leonetti Cellars, Rick Small opened Woodward Canyon Winery in 1981. The friendship between Small and Figgins goes back many years, and Small actually helped Figgins at Leonetti before making his own commercial wines.

Small's first wines were Chardonnay and Cabernet Sauvignon. With their release, he rocketed quickly into the ranks of Washington's best producers, and he's managed to stay there.

Small, a native of Lowden, where the winery is located, shares a small-town background with Figgins. The two became friends in the Army reserve, where they were fellow drill sergeants. They enjoyed cars, golf, and wine. They tasted wines together, and became impassioned home winemakers. They learned their craft together, and for years they were the Walla Walla Valley wine industry.

In the early days, Small continued to manage his family's grain elevators while making wine on the side. Then it became his vocation. Early in the 1990s, when the California-based Chalone Wine Group sought vineyard land in Washington, Small led them to Canoe Ridge. He became a consultant, investor, and partner.

Woodward Canyon produces 8,500 cases of wine yearly. In addition to the flagship Cabernet and Chardonnay, the winery makes Merlot, red and white Bordeaux blends, and the occasional late-harvest Riesling. Small is experimenting with the red Italian varieties Dolcetto and Barbera.

Woodward Canyon Winery

The Best Revenge

The seventeenth-century English poet George Herbert wrote, "Living well is the best revenge." The modern Washington wine industry embraced this concept almost from the very beginning.

The Enological Society of the Pacific Northwest was formed in Seattle in 1975 and soon was busy hauling members by the busload to wineries east of the Cascades to meet the vintners and enjoy their wines. The society organized an annual wine competition that is recognized as one of the best on the West Coast.

Even more important, perhaps, than the competition has been the consumer festival held afterward, for it features not only wine, but also food—lots of food, multicourse affairs for wine lovers.

As the festival grew, its menus became more regionalized. Suddenly it was trendy to pair regional wines with regional foods. As the California, Oregon, and Washington wine industries matured, consumers seemed to gain appreciation for the other good things around them. And those indigenous culinary treasures naturally complemented each region's wines.

Where twenty years ago the Pacific Northwest had salmon, oysters, berries, and Cougar Gold cheese, consumers today have these plus hundreds of other choices in types of scallops, mussels, and oysters; locally produced farm-stead cheeses; new varieties of apples. Ellensburg lamb is considered a must with Washington Cabernet Sauvignon; Merlot is a luscious match with salmon; the lowly asparagus grilled in butter and served with a chilled Sauvignon Blanc is a treat not to be missed.

Food and wine are celebrated throughout Washington wine country with gusto. In addition to the Enological Society festival every August in Seattle, there are many opportunities to celebrate Washington's bounty. Among them:

Taste Washington: A Celebration of Wine and Food. This consumer event features Washington winemakers and their wines matched with local chefs offering tastes of regional dishes. Every March in Seattle.

Prosser Wine and Food Fair. The fair celebrates Eastern Washington wines and specialty foods. Every August at the Prosser Fair Grounds.

Auction of Northwest Wines. This wine and food extravaganza benefits Children's Hospital of Seattle. Every August on the grounds of Chateau Ste. Michelle, in Woodinville.

The World Vinifera Conference. The conference brings together wine industry professionals and the media from around the world and showcases regional cuisine. Every other July (in even years) in Seattle.

of premium wine, Hedges built a chateau-style winery on Red Mountain in Eastern Washington, further encouraging growth there.

Winemaker Mike Januik left Stimson Lane to found his own winery. Bob Betz remains at Stimson Lane as a vice-president, but also is the winemaker for Betz Family Winery, a small operation somewhat reminiscent of the early days in Lloyd Woodburne's garage. Charlie Hoppes, winemaker at Stimson Lane's Canoe Ridge Estate, became winemaker at the new Three Rivers Winery. Eric Dunham left L'Ecole No. 41 to found his own winery.

As the millennium begins, new winery names are on everyone's lips—names like Cayuse and Kestrel, Three Rivers and Pepper Bridge, Birchfield and Bunchgrass and China Bend—lovely names, names that speak of the land. And for all the moving around, there is plenty of talent where it is needed, and plenty of people ready to help finance new projects.

The 1990s also saw the deaths of some of the

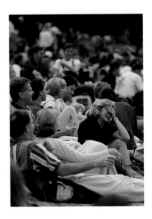

Washington wine industry's greatest friends—among them Erich Steenborg and Alec Bayless in 1991, Lloyd Woodburne in 1992, Angelo Pellegrini in 1993, and Andre Tchelistcheff in 1994.

Washington State now boasts more than a hundred wineries and twice that many independent vineyards. With more than 30,000 acres of winegrapes in the ground, Washington is no longer an outpost, a frontier for wine experimentation. It is a destination.

Right: James Smith of the Meadowbrook String Trio tunes up for an elegant celebration at Chateau Ste. Michelle. *Above:* Guests kick back and enjoy a summer concert on the grounds of Chateau Ste. Michelle.

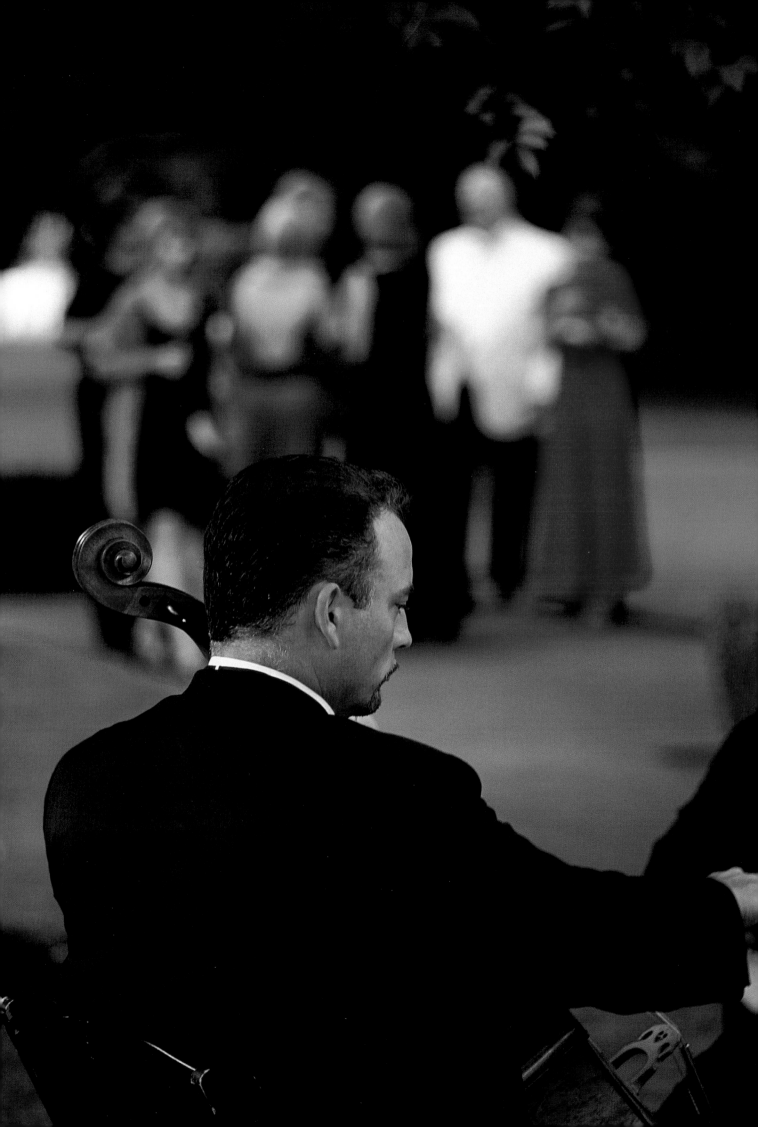

"Making wine? It's as easy as boiling an egg."

—Angelo Pellegrini

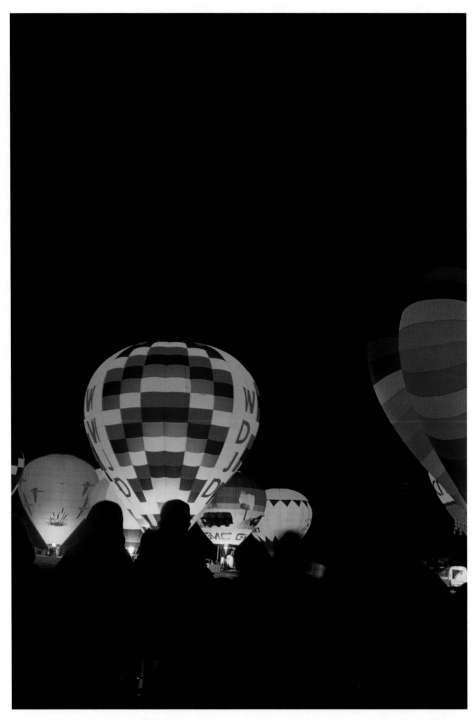

Above: One of many favorite Washington wine country celebrations is the annual Hot Air Balloon Festival held each May in Walla Walla. *Right:* Tourists flock to the tasting room at Columbia Winery in Woodinville. *Overleaf:* Autumn at Red Willow Vineyard. In the distance, a small chapel sits atop the steepest portion of the vineyard overlooking Washington's first Nebbiolo vines planted by Peter Dow and friends many years ago.

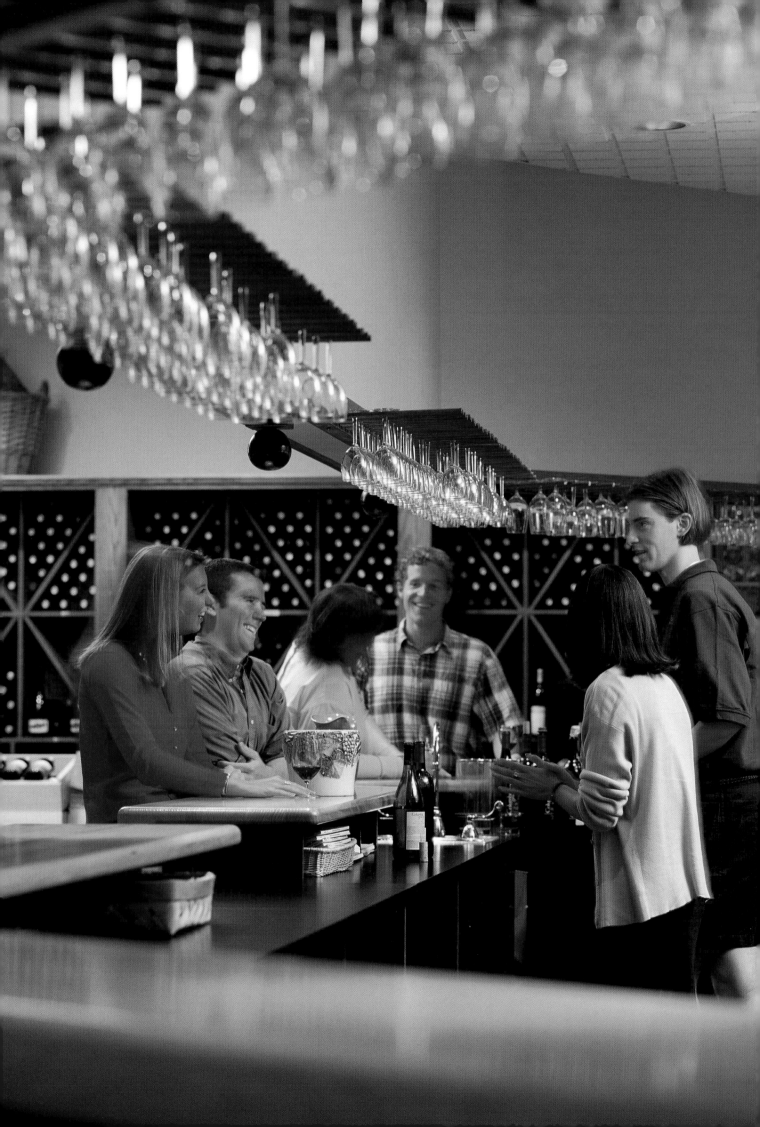

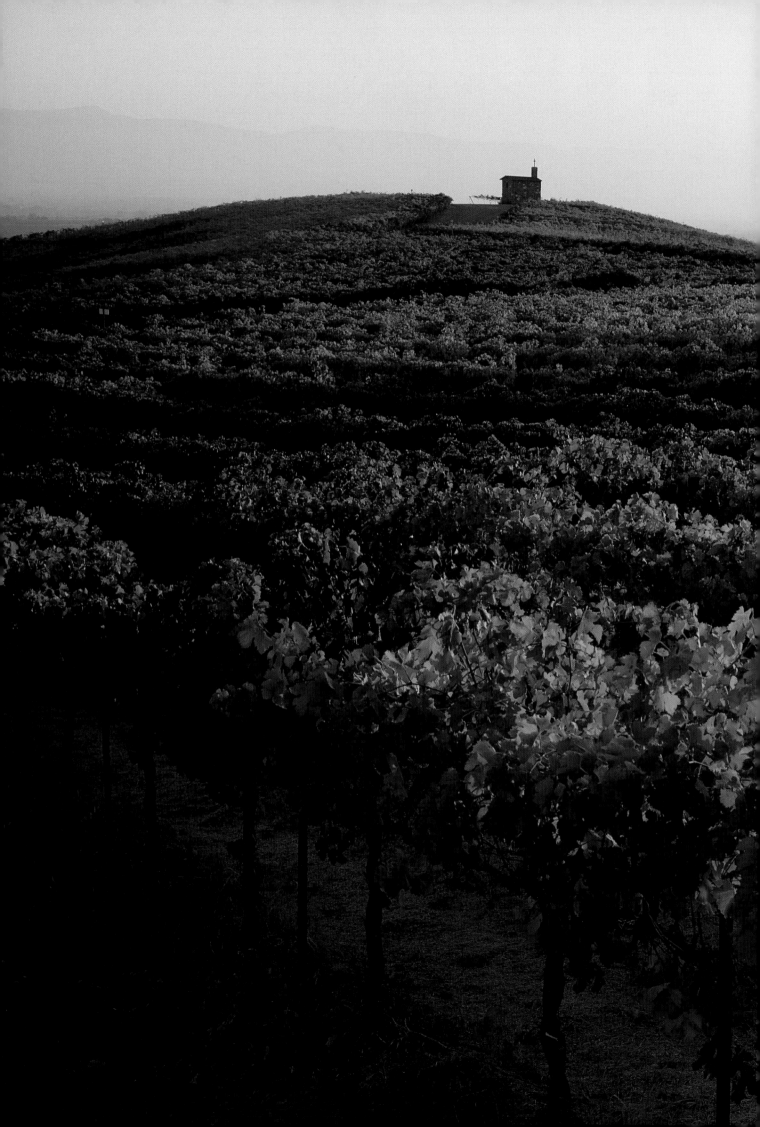

"This is the best Gewürztraminer
made in the United States."
—André Tchelistcheff

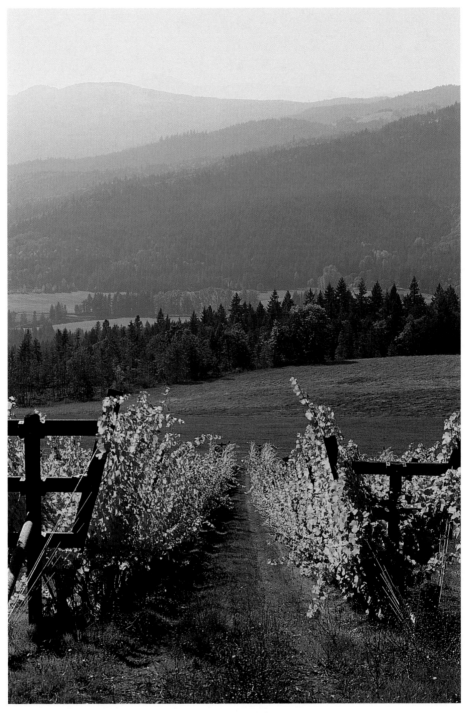

Left: Decorative grape cluster hangs at the entrance of Bainbridge Vineyards and Winery on Bainbridge Island. *Above:* Picturesque Thomas Woodward Vineyard near Husum shows the dramatic contours of the Columbia Gorge.

"Living well is the best revenge."

—George Herbert

Above: Seattle resident Dana Samu sips Chardonnay during the gala multi-course dinner held as part of the annual Auction of Northwest Wines. *Right:* Chateau Ste. Michelle's dark, quiet cellar room sets the scene for many of the winery's VIP events, including private tastings of older wines and elaborate luncheons and dinners prepared by winery chef John Sarich. *Page 112:* Stimson Lane's Cold Creek Vineyard, first planted in 1973, now is known as the André Tchelistcheff Vineyard. It is named to the honor the late Russian-born winemaker who helped transform the California wine industry and served as Chateau Ste. Michelle's consulting enologist from the late 1970s until his death in 1994.

Washington's Appellations and Sub-Appellations

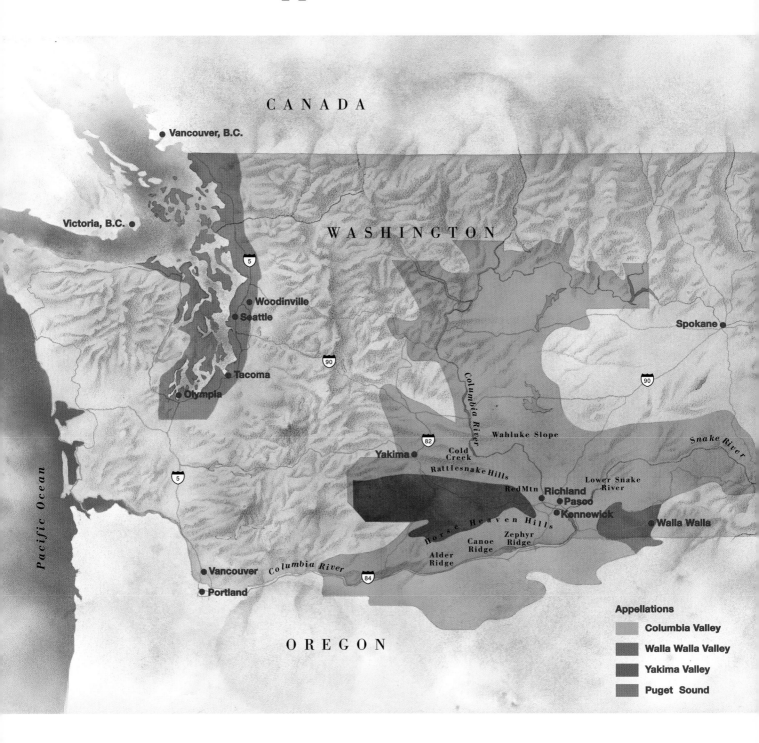

CANADA

Vancouver, B.C.

WASHINGTON

Victoria, B.C.

Woodinville

Seattle

Spokane

Tacoma

Olympia

Columbia River

Wahluke Slope

Snake River

Yakima

Cold Creek

Rattlesnake Hills

Lower Snake River

RedMtn Richland

Pasco

Kennewick

Walla Walla

Horse Heaven Hills

Zephyr Ridge

Canoe Ridge

Alder Ridge

Vancouver

Columbia River

Portland

Pacific Ocean

OREGON

Appellations

- Columbia Valley
- Walla Walla Valley
- Yakima Valley
- Puget Sound

The Wineries of Washington

Alexia Sparkling Wines
18658 142nd Avenue NE
Woodinville WA 98072
(206) 985-2816
E-mail: gordyrawson@msn.com

Ambrosia by Kristy
4921 85th Avenue West
University Place, WA 98467
(253) 307-5156

Andrew Will Winery
12526 S.W. Bank Road
Vashon, WA 98070
(206) 463-3290

Arbor Crest Wine Cellars
4705 N. Fruithill Road
Spokane, WA 99207
(509) 927-9894
www.arborcrestwinery.com

Badger Mountain/
Powers Winery
1106 S. Jurupa Street
Kennewick, WA 99337
(800) 643-WINE (9463)
E-mail: bmvwine@aol.com
www.badgermtnvineyard.com

Bainbridge Island
Vineyards & Winery
682 Highway 305
Bainbridge Island, WA 98110
(206) 842-9463

Balcom & Moe Winery
2520 Commercial Avenue
Pasco, WA 99301
(509) 547-7307
www.balcomandmoewines.com

Barnard Griffin
878 Tulip Lane
Richland, WA 99352
(509) 627-0266

Birchfield Winery
921-B Middle Fork Road
Onalaska, WA 98570
(360) 978-5224

Bonair Winery
500 S. Bonair Road
Zillah, WA 98953
(509) 829-6027
E-mail: winemaker@bonairwine.com
www.bonairwine.com

Bookwalter Winery
894 Tulip Lane
Richland, WA 99352
(877) 667-8300 (Toll Free)
(509) 627-5000
E-mail: info@bookwalterwines.com
www.bookwalterwines.com

Bunchgrass Winery
P.O. Box 1503
Walla Walla, WA 99362
E-mail: rocher@bmi.net

Cadence
432 Yale Avenue North
Seattle, WA 98109
(206) 381-9507
www.cadencewinery.com

Camaraderie Cellars
334 Benson Road
Port Angeles, WA 98363
(360) 452-4964
E-mail: corson@tenforward.com

Canoe Ridge Vineyard
1102 West Cherry
P.O. Box 684
Walla Walla, WA 99362
(509) 527-0885
E-mail: canoerdg@bmmi.net

Cascade Cliffs Winery
and Vineyard
8866 Highway 14, P.O. Box 14
Wishram, WA 98673
(509) 767-1100
E-mail: madamwine@aol.com

Cascade Ridge
14030 N.E. 145th Street
Woodinville, WA 98072
(425) 488-8164

Caterina Winery
905 N. Washington
Spokane, WA 99201
(509) 328-5069
E-mail: ltangen@caterina.com

Cavatappi Winery
9702 N.E. 120th Place
Kirkland, WA 98034
(425) 823-6533

Cayuse Vineyards
17 E. Main Street
Walla Walla, WA 99362
(509) 526-0686
E-mail: info@cayusevineyards.com
www.cayusevinyards.com

Chateau Gallant
647 Gallant Road
Burbank, WA 99323
(509) 545-9570

Chateau Ste. Michelle
14111 N.E. 145th
P.O.Box 1976
Woodinville, WA 98072
(425) 488-1133
www.ste-michelle.com

China Bend Vineyard and Winery
3596 Northport-Flat Creek Road
Kettle Falls, WA 99141
(509) 732-6123
(800) 700-6123
www.chinabend.com

Chinook Wines
Wine Country Road at
Wittkopf Road
P.O. Box 387
Prosser, WA 99350
(509) 786-2725

Claar Cellars
1081 Glenwood Road
Pasco, WA 99301
(509) 266-4449
www.claarcellars.com

Columbia Crest Winery
Highway 221,
Columbia Crest Drive
Paterson, WA 99345-0231
(509) 875-2061
(888) 309-9463
www.columbia-crest.com

Columbia Winery
14030 N.E. 145th
Woodinville, WA 98072
(425) 488-2776
www.columbiawinery.com

Coventry Vale Winery
Wilgus & Evans Roads
P.O. Box 249
Grandview, WA 98930
(509) 882-4100

Covey Run Vintners
1500 Vintage Road
Zillah, WA 98953
(509) 829-6235
www.coveyrun.com

DeLille Cellars/ Chaleur Estate
P.O. Box 2233
Woodinville, WA 98072
(425) 489-0544
E-mail: DeLille@compuserve.com
www.delillecellars.com

Di Stefano Winery
P.O. Box 2048 (for mailing only)
12280 Woodinville Drive,
Woodinville Corporate Center,
Suite #1
Woodinville, WA 98072

Dunham Cellars
150 E. Boeing
Walla Walla Regional Airport
Walla Walla, WA 99632
(509) 529-4685
E-mail: dunham@wwics.com

E.B. Foote Winery
127-B S.W. 153rd Street
Burien, WA 98166
(206) 242-3852
Fax: (206) 433-0788

Eaton Hill Winery
530 Gurley Road
Granger, WA 98932
(509) 854-2220

Facelli Winery
16120 Woodinville-
Redmond Road N. E. #1
Woodinville, WA 98072
(425) 488-1020

FairWinds Winery
1924 Hastings Avenue, W.
Port Townsend, WA 98368
(360) 385-6899

Glen Fiona
Post Office Box 2024
Route 4, Box 251-AA,
Mill Creek Road
Walla Walla, Washington 99362
(509) 522-2566
E-mail: syrah@glenfiona.com
www.glenfiona.com

Gordon Brothers Cellars
5960 Burden Boulevard
Pasco, WA 99301
(509) 547-6331
E-mail: info@gordonwines.com
www.gordonwines.com

Greenbank Cellars, Ltd.
3112 S. Day Road
Greenbank, WA 98253
(360) 730-1720
E-mail: wine@whidbey.com
www2.whidbey.com/wine

Hedges Cellars
195 NE Gilman Boulevard
Issaquah, WA 98027
(425) 391-6056

Hedges Cellars at Red Mountain
53511 N. Sunset Road
PRNE
Benton City, WA 99320
(509) 588-3155

Hinzerling Winery
1520 Sheridan
Prosser, WA 99350
(509) 786-2163
E-mail: info@hinzerling.com
www.hinzerling.com

The Hogue Cellars
Wine Country Road - P.O. Box 31
Prosser, WA 99350
(509) 786-4557

Hoodsport Winery
N. 23501 Highway 101
Hoodsport, WA 98548
(360) 877-9894
(800) 580-9894
E-mail: hoodsport@hctc.com
www.hoodsport.com

Horizon's Edge Winery
4530 East Zillah Drive
Zillah, WA 98953
(509) 829-6401
E-mail: mtwinery@aol.com
members.aol.com/wawinery/index
.html

Hunter Hill Vineyards
2752 W. McManamon Road
Othello, WA 99344
(509) 346-2736

Hyatt Vineyards
2020 Gilbert Road
Zillah, WA 98953
(509) 829-6333

Januik Winery
7401 NE 122nd Street
Kirkland, WA 98034
(425) 825-5710
www.januikwinery.com
E-mail: mike@januikwinery.com

Kestrel Vintners
Prosser Wine & Food Park
2890 Lee Road
Prosser, WA 99350
(509) 786-CORK (2675)
(888) 343-CORK

Kiona Vineyards
44612 North Sunset NE
Sunset Road
Benton City, WA 99320
(509) 588-6716

Knipprath Cellars
S. 163 Lincoln Street
Spokane, WA 99201
(509) 977-7792

L'Ecole No 41
41 Lowden School Road
Lowden, WA 99360
(509) 525-0940
E-mail: info@lecole.com
Web site: www.lecole.com

Latah Creek Wine Cellars
E. 13030 Indiana Avenue
Spokane, WA 99216
(509) 926-0164
(800) LATAHCREEK

Leonetti Cellar
1321 School Avenue
Walla Walla, WA 99362

Lopez Island Vineyards
724 Fisherman Bay Road
Lopez Island, WA 98261
(360) 468-3644
E-mail: lopezvineyards@yahoo.com

Lost Mountain Winery
3174 Lost Mountain Road
Sequim, WA 98382
(360) 683-5229
E-mail: wine@lostmountain.com

Market Cellar Winery
1432 Western Avenue
Seattle, WA 98101
(206) 622-1880

Matthews Cellars
16116 140th Place NE
Woodinville, WA 98072
(425) 487-9810
E-mail: mattl@matthewscellars.com
www.matthewscellars.com

McCrea Cellars
13443 - 118th Avenue S.E.
Rainier, WA 98576
(360) 458-9463

Mount Baker Vineyards
4298 Mount Baker Highway
Deming, WA 98244
(360) 592-2300

Mountain Dome Winery
16315 E. Temple Road
Spokane, WA 99217
(509) 928-2788
(888) 928-2788
E-mail: manz@mountaindome.com
www.mountaindome.com

Oakwood Cellars
40504 North Demoss Road
Benton City, WA 99320
(509) 588-5332

Olympic Cellars
255410 Highway 101
Port Angeles, WA 98362
(360) 452-0160
E-mail: wines@olympiccellars.com
www.olympiccellars.com

Pasek Cellars
511 S. First
Mt. Vernon, WA 98273
(360) 336-6877

Patrick M. Paul Vineyards
1554 School Avenue
Walla Walla, WA 99362
(509) 522-1127
E-mail: paulte@wwics.com

Paul Thomas
Estate and Winery
2310 Holmanson Road
Sunnyside, WA 98944
(509) 837-5605
Tasting Room: (509) 829-6990
www.corusbrands.com

Pontin del Roza
35502 North Hinzerling Road
Prosser, WA 99350
(509) 786-4449
E-mail: pontindelroza@msn.com

Portteus Winery
5201 Highland Drive
PO Box 1444
Zillah, WA 98953
(509) 829-6970
E-mail: port4you@aol.com

Preston Premium Wines
502 E. Vineyard Drive
Pasco, WA 99301
(509) 545-1990

Quilceda Creek Vintners
11306 52nd Street SE
Snohomish, WA 98290
(360) 568-2389

R. L. Wine Company
3051 42nd Avenue West
Seattle, WA 98199
Attn: Randy Leitman
(206) 283-7688

Rainey Valley Winery
8178 US Highway 12
Glenoma, WA 98336
(360)498-3060
(800)941-8461
E-mail: rvw@myhome.net
www.raineyvalleywinery.com

Rich Passage Winery
7869 NE Day Road West,
Building A
Bainbridge Island, WA 98110
(206) 842-8199

Saintpaulia Vintners
18302 - 83rd Avenue SE
Snohomish, WA 98296
(360) 668-8585
E-mail: paulshinoda@msn.com

Salishan Vineyards
35011 North Fork Avenue
LaCenter, WA 98629
(360) 263-2713

San Juan Vineyards
2000 Roche Harbor Road
P.O. Box 1127
Friday Harbor, WA 98250
(360) 378-9463
E-mail: sjvineyards@rockisland.com

Seth Ryan Winery
35306 Sunset Road
Benton City, WA 99320
(509) 588-6780
E-mail: ronandjo@televar.com
www.sethryan.com

Seven Hills Winery
469 Ransom Road
Walla Walla, WA 99362
Tasting Room: 235 E. Broadway
Milton-Freewater, OR 97862

SilverLake Sparkling Cellars
17721-132nd Avenue N.E.
Woodinville, WA 98072
(425) 486-1900

Sky River Meadery
32533 Cascade View Drive
P.O. Box 869
Sultan, WA 98294
(360) 793-6761
E-mail:denice@skyriverbrewing.com
www.skyriverbrewing.com

Soos Creek Wine Cellars
20404 140th Avenue S.E.
Kent, WA 98042
(253) 631-8775
E-mail: sooscreek@mindspring.com

Staton Hills Winery
71 Gangl Road
Wapato, WA 98951
(509) 877-2112

Tagaris Winery
P.O. Box 5433
Kennewick, WA 99336
Retail Store:
1625 W. A Street, Unit E
Pasco, WA 99301

Teft Cellars
1320 Independence Road
Outlook, WA 98938
(509) 837-7651
E-mail: info@tefftcellars.com
www.tefftcellars.com

Terra Blanca Vintners
34715 North Demoss Road
Benton City, WA 98320
(509) 588-6082
E-mail: kpilgrim@terrablanca.com
www.terrablanca.com

Three Rivers Winery
P.O. Box 402
Walla Walla, WA 99362
(509) 526-WINE (9463)
www.threeriverswinery.com

Thurston Wolfe Winery
3800 Lee Road, Suite C
Prosser, WA 99350
(509) 786-3313

Tucker Cellars
70 Ray Road
Sunnyside, WA 98944
(509) 837-8701

Vashon Winery
12629 S.W. Cemetery Road
Vashon, WA 98070
(206) 463-2990

Baron Manfred Vierthaler Winery
17136 Highway 410 East
Sumner, WA 98390
(253) 863-1633

Walla Walla Vintners
Mill Creek Road, P.O. Box 1551
Walla Walla, WA 99362
(509) 525-4724

Washington Hills Cellars
111 East Lincoln Avenue
Sunnyside, WA 98944
(509) 839-WINE (9463)

Waterbrook Winery
31 East Main Street
Walla Walla, WA 99362
(509) 522-1262
E-mail: wbrook@bmi.net
www.waterbrook.com

Whidbey Island Vineyard & Winery
5237 S. Langley Road
Langley, WA 98260
(360) 221-2040
Email: winery@whidbeyisland.com

White Heron Cellars
10035 Stuhlmiller Road
Quincy, WA 98848
(509) 797-9463

Widgeon Hill Winery
121 Widgeon Hill Road
Chehalis, WA 98532
(360) 748-0407
(360) 736-2815
E-mail: winery@whidbeyisland.com

Wildflower Winery, LLC
508 Whitman Street
Walla Walla, WA 99362
(509) 529-2474
E-mail: isenhowe@bmi.net
www.wildflowerwinery.com

Willow Crest Winery
55002 N. Gap Road
Prosser, WA 99350
(509) 786-7999
E-mail: wilowine@bentonrea.com

Wilridge Winery
1416 - 34th Avenue
Seattle, WA 98122
(206) 325-3051
Fax: (206) 447-0849

Wind River Cellars
196 Spring Creek Road
Husum, WA 98623
(509) 493-2324
E-mail: windriverwines@gorge.net

Wineglass Cellars
260 North Bonair Road
Zillah, WA 98953
(509) 829-3011
E-mail: wgcllrs@ibm.net

Woodward Canyon Winery
11920 W. Highway 12
Rt. 1, Box 387
Lowden , WA 99360
(509) 525-4129

Worden Winery
7217 W. 45th
Spokane, WA 99204
(509) 455-7835
(509) 838-4723
E-mail: Wordenwine@aol.com

Yakima River Winery
143302 North River Road
Prosser, WA 99350
(509) 786-2805
E-mail:
 redwine@yakimariverwinery.com
www.yakimariverwinery.com

Index

Page numbers in **Bold face** indicate photographs.

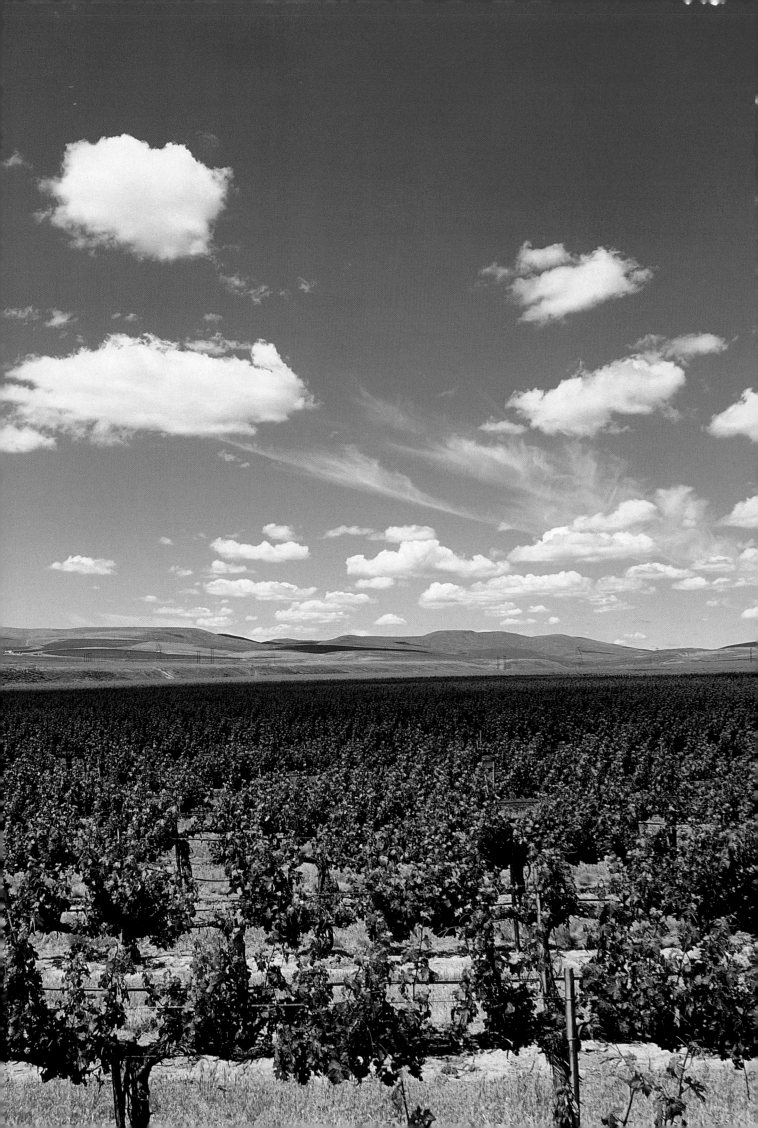